BORNE

DRYPOINTS · ETCHINGS
COLOR DRYPOINTS

Drypoints, Etchings
and Color Drypoints
In Permanent Collections

Metropolitan Museum of Art, New York
British Museum, London
Victoria and Albert Museum, London
National Gallery of Art, Washington
New York Public Library
Smithsonian Institution, United States National Museum,
Collection of Fine Arts, Washington
Smithsonain Institution, United States National Museum,
Division of History and Technology, Washington
New-York Historical Society, Museum of American History and Art
Israel Museum, Jerusalem
Library of Congress, Washington
Philadelphia Museum of Art
Museum of Modern Art, New York
The Brooklyn Museum, New York
Dallas Museum of Fine Arts
The Fine Arts Museums of San Francisco
Achenbach Foundation for Graphic Arts
Museum of Fine Arts, Houston
Montgomery Museum of Fine Arts, Montgomery, Alabama
San Diego Museum of Art
Everson Museum of Art, Syracuse, New York
Newark Museum, New Jersey
Syracuse Museum of Fine Arts, Syracuse, New York
The Detroit Institute of Arts
Wadsworth Atheneum, Hartford, Connecticut
Yale Art Gallery
Boston Public Library
The Currier Gallery of Art, Manchester, New Hampshire
State of New Jersey, Department of Conservation and Development,
State House Annex, Trenton
Georgia Museum of Art, The University of Georgia, Athens
The Saint Louis Museum, Missouri

BORNE

DRYPOINTS · ETCHINGS
COLOR DRYPOINTS

Text by R.S. Biran

Abaris Books · New York

First Edition
Copyright 1980 © by Mortimer Borne
All rights reserved.

Published by Abaris Books, Inc.
24 West 40 Street
New York, N.Y. 10018

ISBN 0-913870-96-X (Cloth edition)
Library of Congress Catalog Card Number 80-66487

Contents

Introduction 6

Color Plates 8

Quality in Etching and Drypoint 40

Black and White Plates 42

Documentation
 Catalogs and Commentaries 186

Bibliography 190

List of Plates 191

Introduction

The only artists who will survive are those who have a higher ambition than merely to follow contemporary fashion, and who can show that they have their own inevitable and individual style, their own original vision of the material and spiritual worlds.

Claude Roger-Marx

The art of the American artist, Mortimer Borne (1902 —), is fascinating in its spontaneity and versatility. His works are formally masterful, yet intimate, subtle in their interpretations, reflecting sensitivity to form and character, space and atmosphere, and line. His innovations in painting, sculpture, drawing and woodcut, and his invention of color drypoint, place him high in the ranks of master artists. (See Bibliography.) His diversity of subject matter, too, is phenomenal.

Although Borne has made more than four hundred prints, this book is limited to illustrations of sixteen color drypoints and seventy-four black and white drypoints and etchings. His subject matter includes scenes of New York and Jerusalem, portraits, landscapes, fantasy, and other diverse themes. Like Rembrandt, Borne captures the spiritual essence of his subjects.

Mortimer Borne's love affair with New York spans a period of more than fifty years and continues today. The so-called "ugly" elevated lines and "ugly" buildings of the city can appear beautiful to an artist whose eyes feast on the incredible variety of patterns of line and tone. For him, the old "El" turns into a symphony of linear rhythms and tonalities.

The aritst's choice of New York subjects was determined primarily by the graphic images that attracted his eye as he wandered through the streets with his folding stool and a specially constructed box containing his copper plate and diamond-pointed drypoint needle. Where he stopped to work also depended on finding the physical circumstances that would enable him to sit down and work directly on the copper plate without being jostled by the passing crowds. He recalls the curious passersby who paused to peer at the glistening lines on his plate as he was working — some shaking their heads in disbelief that those shiny scratches could possibly represent an image of what was in front of him. He also remembers their admiration for his courage in cutting directly into the metal, without preliminary drawing, without hesitation.

The group of drypoints and etchings of New York scenes dates from 1926 on. Some of the views are the same today; others constitute a permanent record of what the city was like in earlier days. Although the prints may involve facets of historical or technical interest, they are always dominated by esthetic excellence.

In 1935, on the occasion of his one-man show of prints at the Gallery Hachadasha (New Gallery) in Jerusalem, Borne traveled to the Holy Land with the intention of making some drypoints there. His trip was made possible through the generosity of the Diamond Jubilee Fund of King Solomon Lodge No. 279. The Trustees of the Masonic Lodge included William

L. Tasch, William Neugass, Emanuel Voss and George P. Frenkel. Borne worked for a number of months, mainly in the Old City of Jerusalem and the Bokhara and Mea Shearim sections of the city. He produced about thirty plates, some of which were included along with other subjects in one-man shows at the Corcoran Gallery of Art, Washington, in 1941; the Museum of Fine Arts, Montreal, in 1942; the Currier Gallery of Art, Manchester, New Hampshire, in 1945; and in subsequent exhibitions. Several of these drypoints are reproduced in this book.

During his stay in Jerusalem, Borne also visited with S.J. Agnon (who later won the Nobel Prize for literature in 1966) and made a number of portrait drawings of the writer. One of these was reproduced in the *New York Times Book Review* of February 21, 1937.

Borne's earliest print in a museum collection dates from 1926, when he was only twenty-three years old. His earliest one-man show of drypoints occurred in Shanghai, China, in 1932. It received excellent reviews, one appearing in *The North-China Sunday News*, September, 1932. This was followed by other important one-man shows. From January 31 to May 4, 1980, Borne's prints were shown at the British Museum (prints from the Museum's permanent collection), in an exhibition entitled, "American Prints 1879-1979." Another one-man show is scheduled for September 1980, at the New-York Historical Society, Museum of American History and Art. It will include about eighty-five drypoints and etchings of New York subjects from the Museum's permanent collection.

Fully aware of the new approaches to art in the twentieth century, Borne nevertheless does not succumb to the fashions of the day. It is his conviction that specialization in subject matter or in any one idiom — figurative, impressionist, cubist, surrealist, abstract expressionist, color field — robs the artist of the opportunity for free exploration of his creative capabilities, and constitutes a kind of fanaticism detrimental to the free play of imagination.

Color Drypoints

Mortimer Borne, master of the black and white drypoint technique, is the inventor of Color Drypoint. For each subject, he uses three copper plates in which yellow, blue, and red lines of differing intensities combine in various proportions to produce an inexhaustible array of colors, tones, and textures. The uniqueness of color drypoint lies in the fact that it is made up of drypoint *lines* in color. This is very different in character from those prints sometimes misnamed "color drypoints" in which a drypoint line (usually used as a contour) is superimposed upon a tone medium such as aquatint, mezzotint, or roulette.

Borne's invention is important in that it makes possible effects not attainable with any other medium.

Trinity Church, Wall Street
Color Drypoint 10 x 8 inches 1940

The first Protestant Episcopal Church was established in New York in 1698. The present building, Trinity Church, at Broadway and Wall Street, was built in 1846 and is the third building on this historic site. It was designed by Richard Upjohn, one of the famous architects of that period. This beautifully proportioned building, 79 feet wide and 166 feet long, is enclosed by skyscrapers. The churchyard surrounds the church on the north, west and south sides. Here lie such honored dead as Alexander Hamilton, Robert Fulton, and William Bradford, who was the earliest champion of the freedom of the press and founder of the first newspaper, The Gazette.

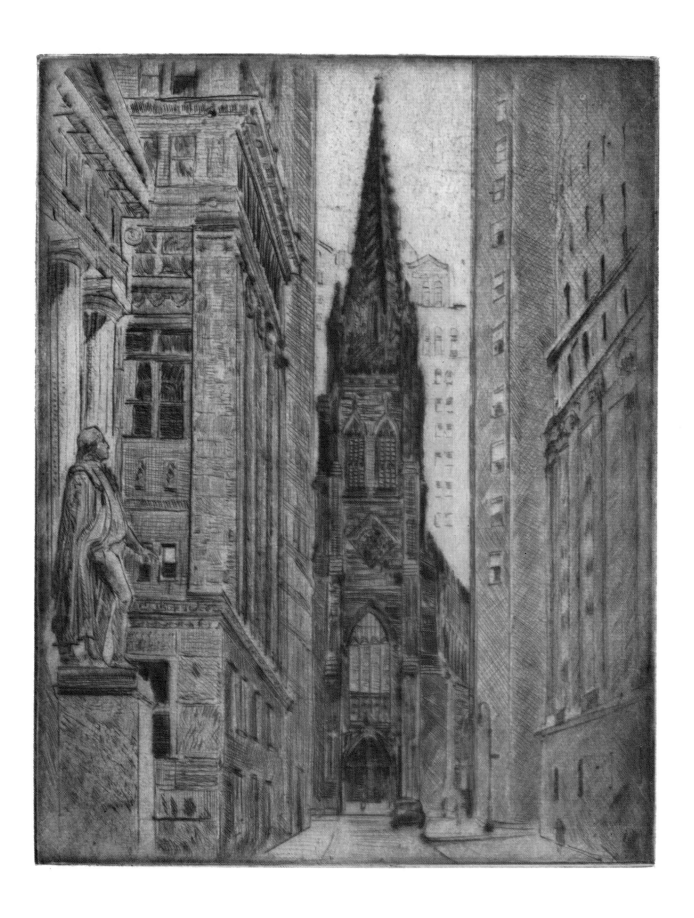

Mahopac Landscape
Color Drypoint 11 x 14 inches 1945

*The distinctive quality of Borne's landscapes arises from his direct contact
with nature, his judgement of tone values, his sense of structure, and his
feeling for atmosphere. The subtlety of such prints lies in Borne's under-
standing of light and its reflections.*

 With Borne, nature is no longer just seen, *as in photography or strictly
academic depiction, but totally* experienced. *His rendering is simple and un-
affected; his approach is subjective.*

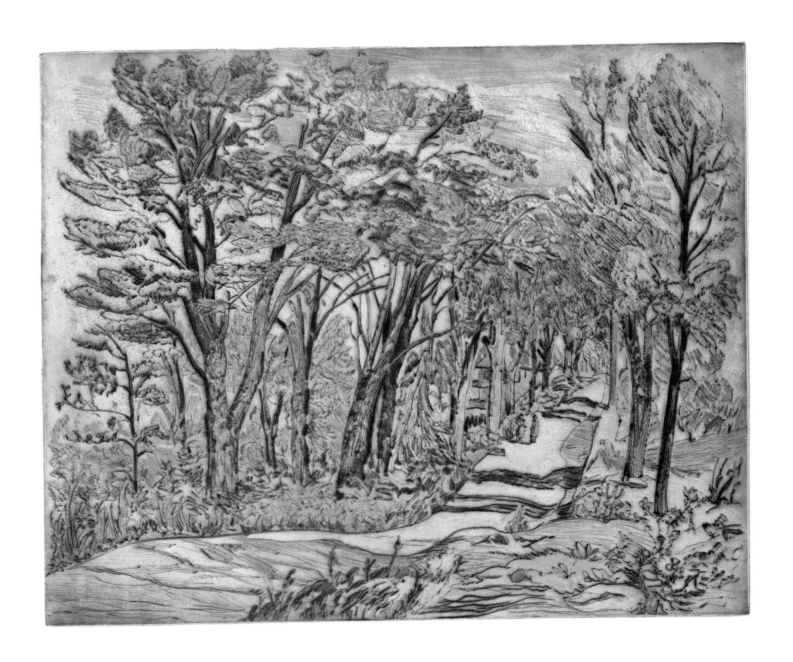

Stone Street, Sunday
Color Drypoint 8 x 10 inches 1940

It is difficult to imagine that Stone Street, in the heart of New York's financial district, can look so charming and serene. It must be remembered, however, that this was the artist's vision of it on a Sunday, when the hustle and bustle of mid-week was absent.

Stone Street branches off from Broad Street; the massive buildings of the financial district are not seen here.

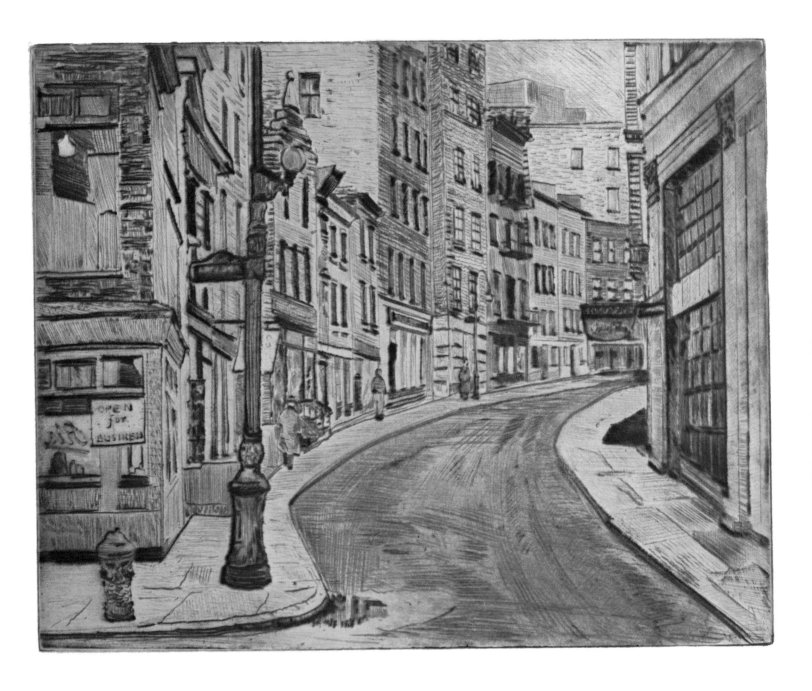

Church of the Holy Trinity, Brooklyn Heights
Color Drypoint 10 x 7¾ inches 1947

This Protestant Episcopal church, built in 1847 by Minard Lefever, well-known designer of many Brooklyn churches, is located at the northeast corner of Clinton and Montague Streets in Brooklyn Heights. The artist's studio was nearby, at 130 State Street.

The quiet, non-commercial Montague Street contrasts strongly with the financial district of Wall Street in Manhattan, where Trinity Church (also Protestant Episcopal) is located.

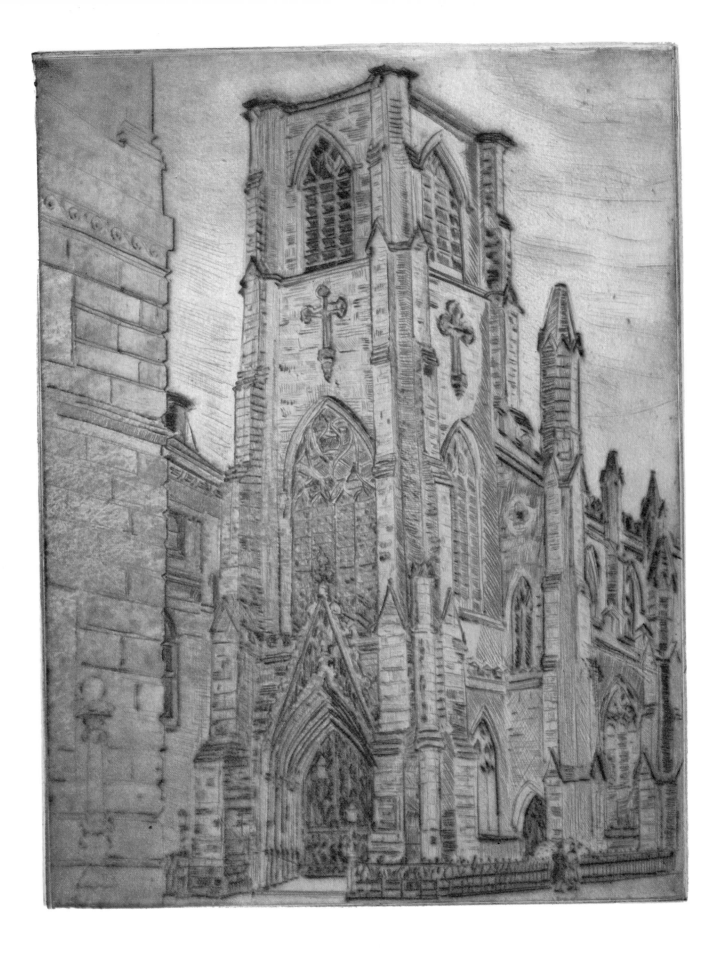

The Road
Color Drypoint 7 x 10 inches 1944

Tree-lined country roads in wintertime, when rhythmic configurations are most apparent, have always fascinated the artist. Here Borne has captured a glowing fragment of nature. His rendering of light, combined with judicious use of color, heightens the poetry of the scene.

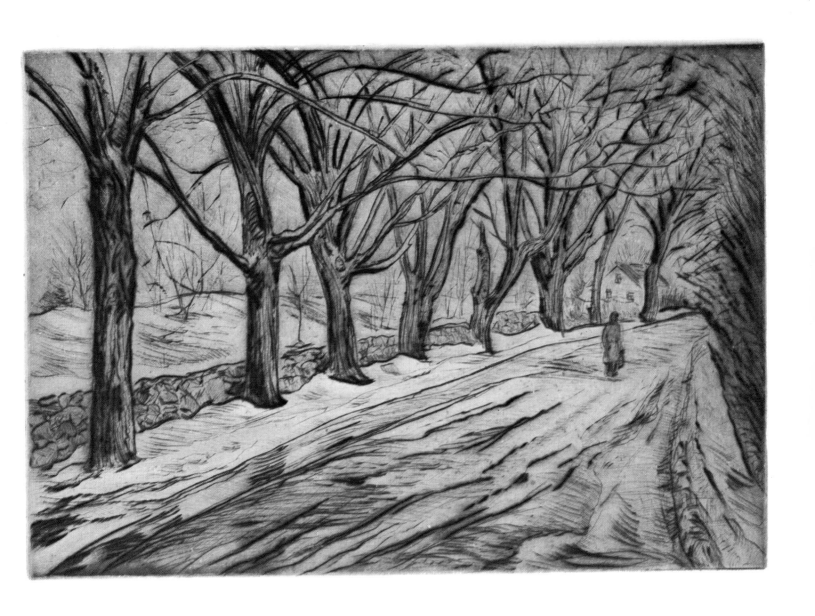

Fantasy
Color Drypoint 7 x 10 inches 1946

In Borne's imagination, the idea of "homecoming" encompasses anthropo-morphic symbolism. In this drypoint, the distinction between animate and inanimate elements disappears. Tree, man, horse, and objects are in com-munication with each other as integral members of a unified vision.

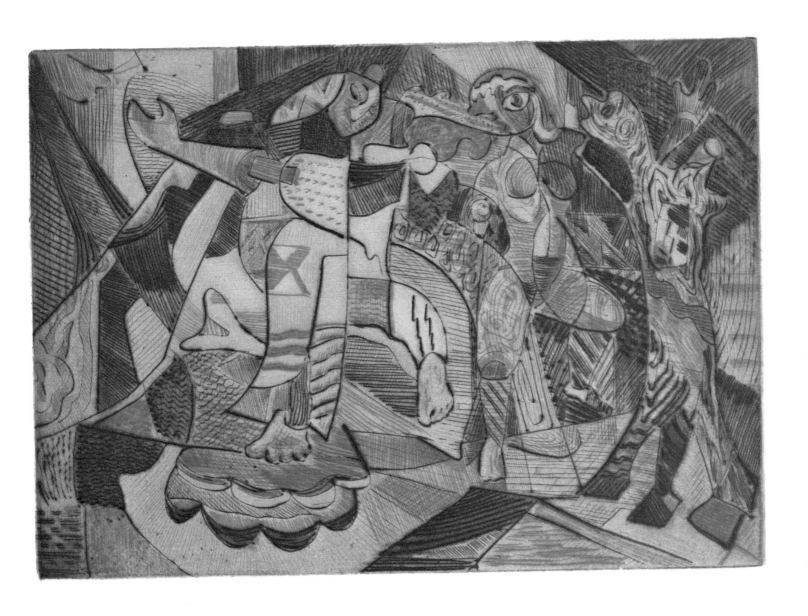

Biological Abstraction [Microcosm]
Color Drypoint 11 x 15 inches 1943

*There is no conflict in Borne between representational and nonrepresenta-
tional art. The freedom of the artist demands that he express himself with
the means best suited to the occasion. He is keenly aware of the multiplicity
of the world and the supreme value of contemplation.*

*This print depicts a world which is opaque to our everyday vision but is
nevertheless a component of our awareness, supplied by the electron micro-
scope and other extensions of our eyes. The existence of the microscopic en-
tities which make up our environment is here imaginatively revealed.*

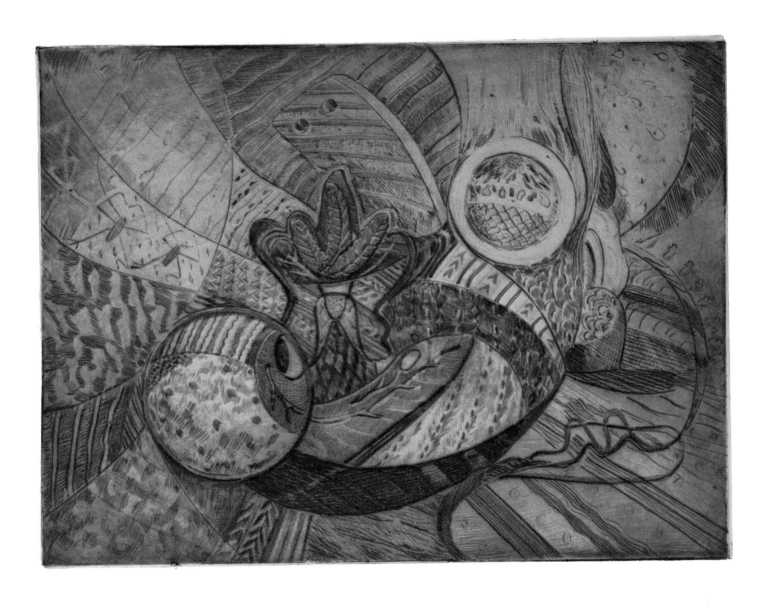

Fundamentals
Color Drypoint 11 x 14 inches 1944

*The primary needs for survival of all creatures, man included, are here de-
picted in the abstract idiom.*

*In this print, the artist brings out the particular potential of his color dry-
point technique, that is, to express color areas with lines of various hues,
sizes, directions, and proximities.*

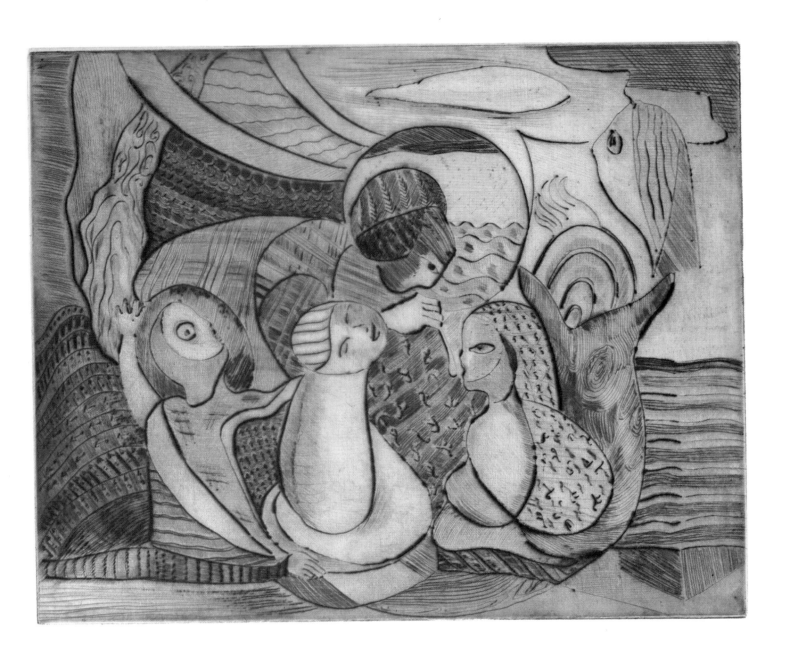

Moses and Aaron Before Pharaoh
Color Drypoint 16 x 20 inches 1954

*This large color drypoint was both a technical and an esthetic challenge for
the artist. Such a size had apparently never been attempted in the pure dry-
point technique.*

*The theme recalls the biblical account of Moses and Aaron before Phar-
aoh. One can almost hear the plea, "Let my people go!"*

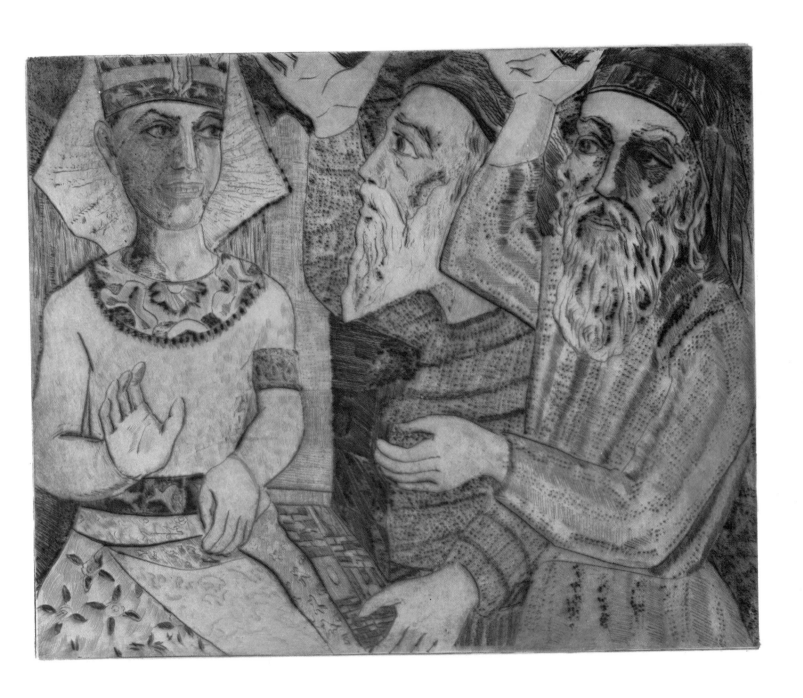

Parade
Color Drypoint 10 x 12 inches 1955

*This is the artist's symbolic conception of the spirit of a parade. Here are
the men, horses and banners, the feel of the drum beat, and the kind of
mass hysteria which characterizes all parades, especially military ones.*
* The artist has adapted the degree of abstraction to the character of the
concept. The image is intended to evoke that rhythm associated with
watching a parade.*

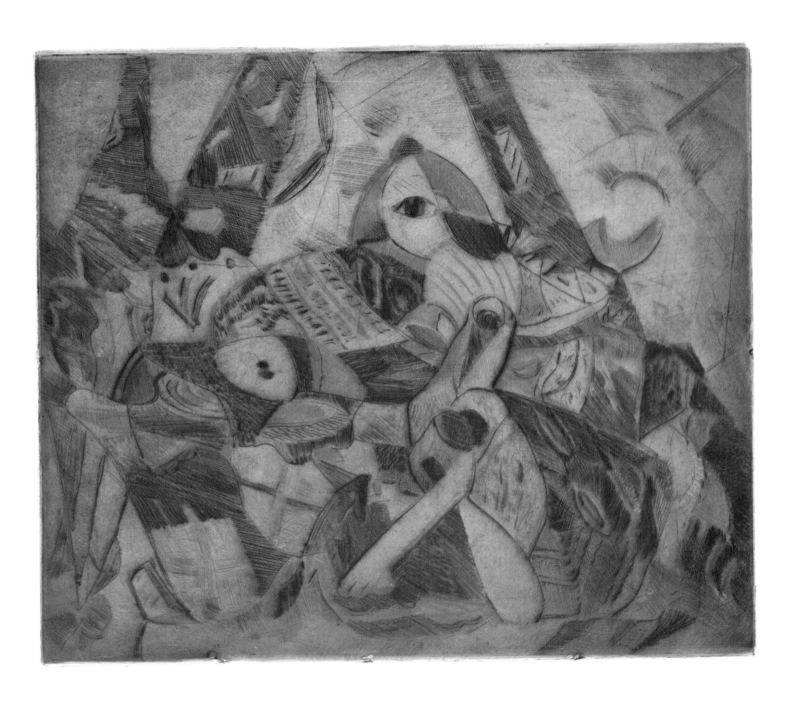

The Couple
Color Drypoint 14 x 10 inches 1955

*The artist's reaction to a couple he knew, where the female seemed to domi-
nate, was the starting point for this print. As the work progressed, how-
ever, the excitement of creativity centered around the play of forms, colors
and textures.*

 *In abstract as well as representational art, the formal organization, expres-
siveness, and originality are an index of artistic quality.*

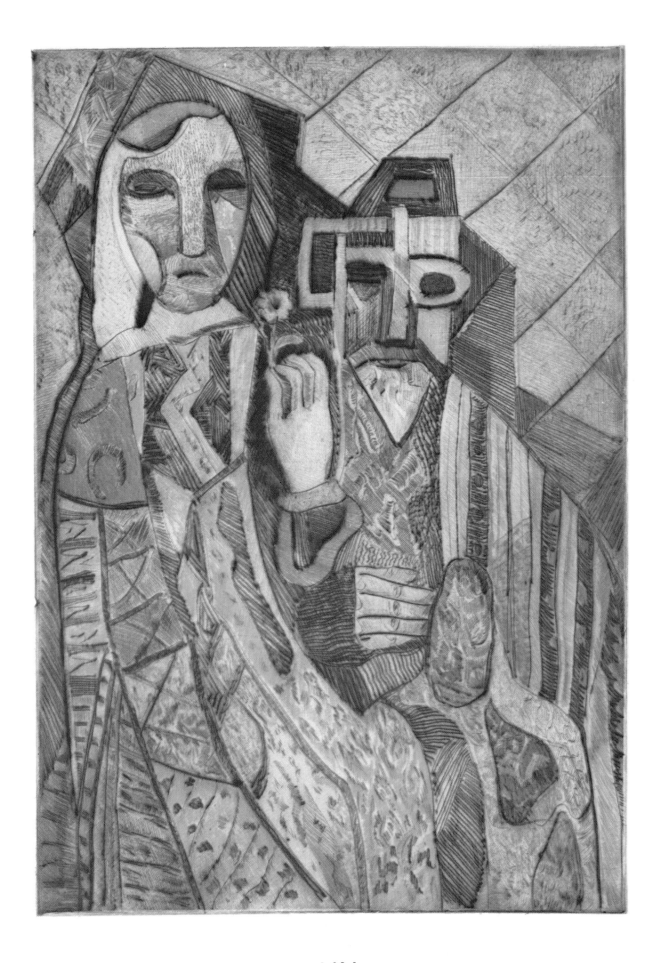

Conversation
Color Drypoint 12 x 15 inches 1969

This is an abstract rendering of interaction between individuals, the dominance of one over the other; the confrontation is expressed in visual terms of line, form and color.

Many influences contributed to the realization of this concept, including the artist's experience with Chromatic Wood Sculpture (a technique that he invented), which demands simplification of forms toward the geometric.

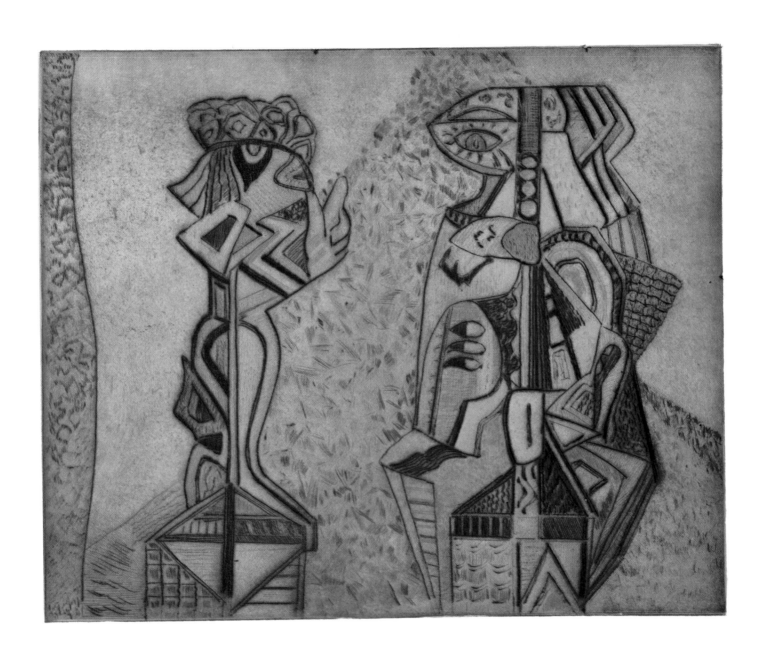

Burliuk in His Studio
Color Drypoint 9 x 12 inches 1937

In 1937, Burliuk, the Russian-American painter, and his wife, Mariusa, invited Borne to stay with them for a week or so at their home in Hampton Bays, Long Island.

While Burliuk was painting with Mariusa at his side, Borne took out his diamond-pointed needle and made this drypoint directly on the copper plate.

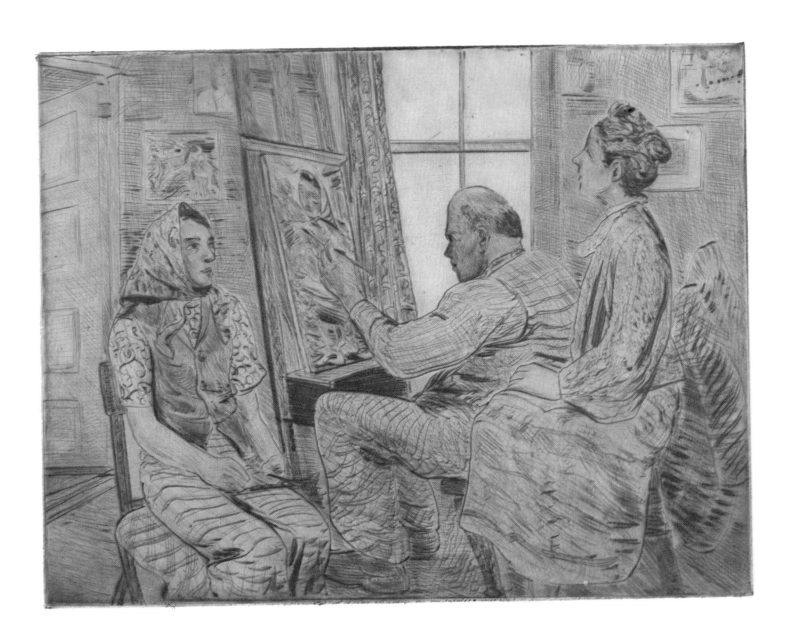

[33]

Odalisque
Color Drypoint 14 x 11 inches 1944

The odalisque, a female slave or concubine in a harem, was a favorite subject of artists right up to the twentieth century, including Matisse.
* The wealth of possible combinations of lines in blue, yellow and red is exploited here to produce a romantic, decorative effect.*

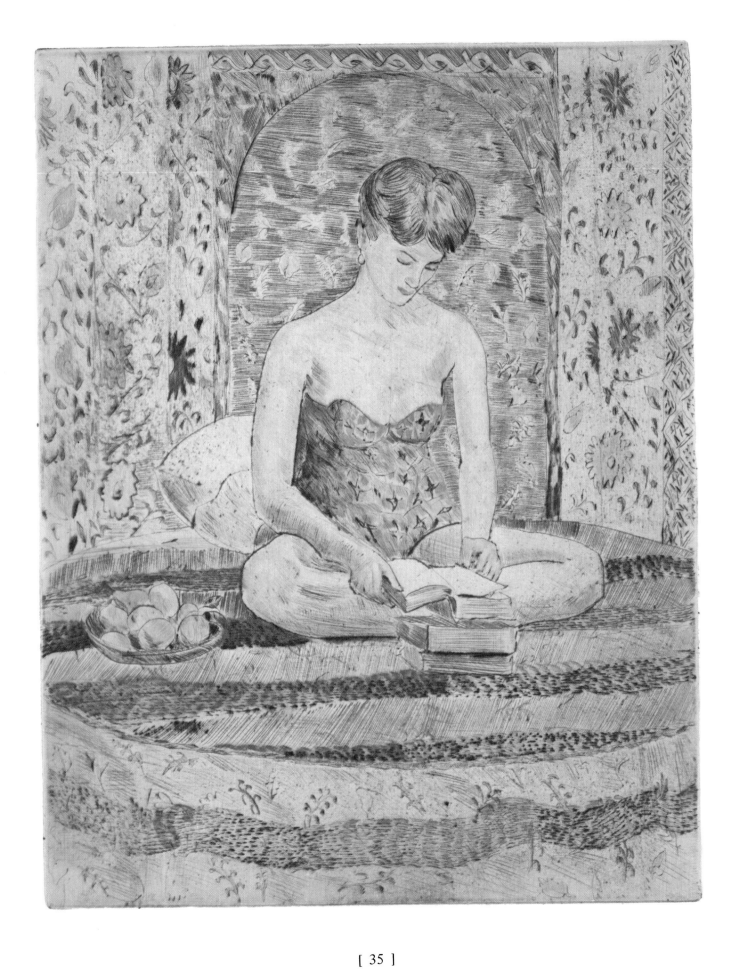

The Stoop
Color Drypoint 11 x 14 inches 1949

This is a street in Brooklyn Heights on a summer day. The air indoors is hot and the neighborhood's newly arrived tenants sit outdoors, where life takes on a carnival air.

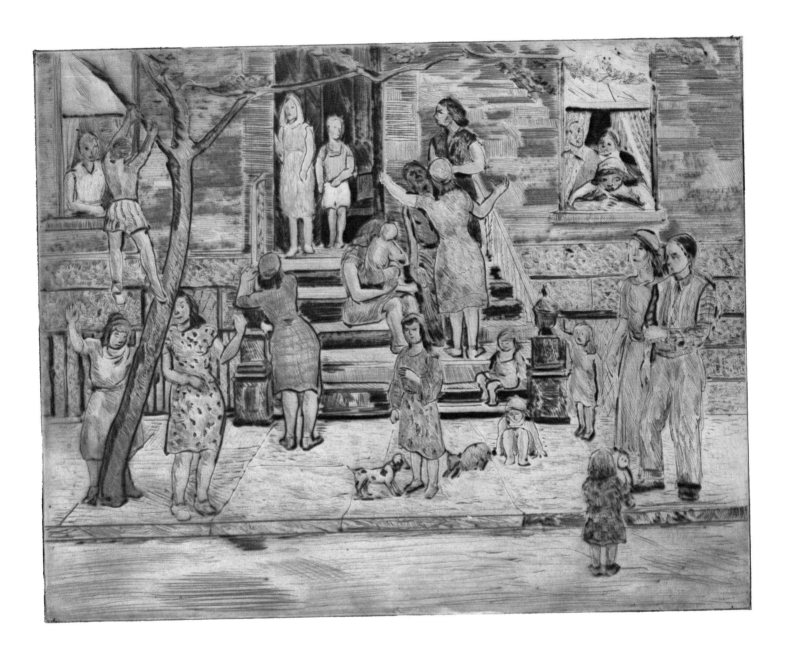

The Violins
Color Drypoint 12 x 9 inches 1966

Philosophical ideas attract Borne. His imagination was stimulated by a book about panpsychism — the doctrine that each object in the universe has either a mind or an unconscious psyche. Here he depicts two violins in communion with each other through the vibration of sound.

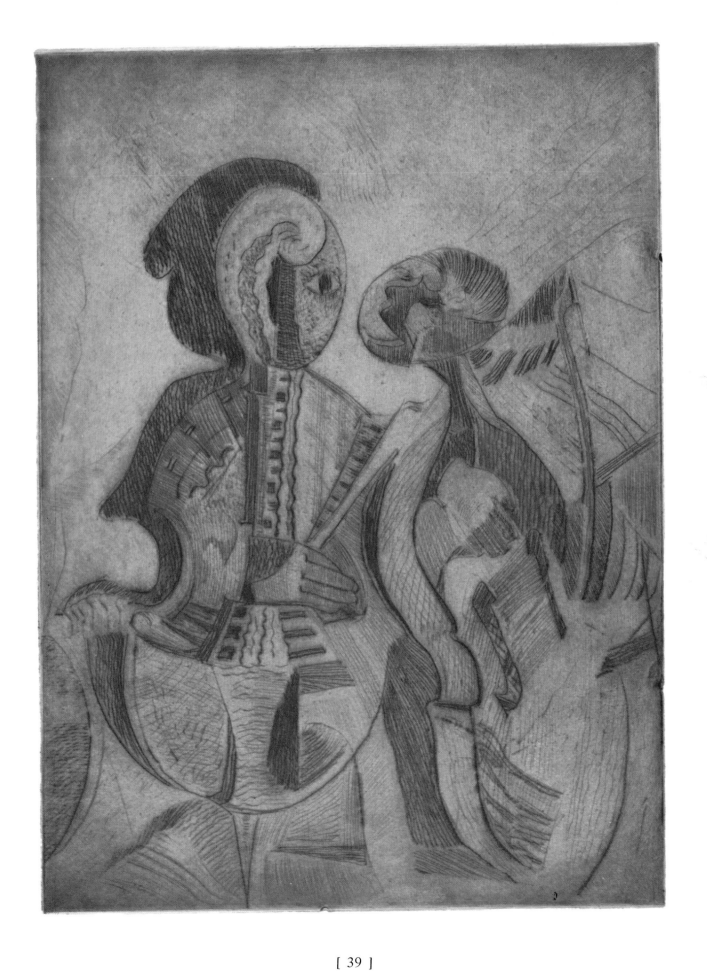

Quality in Etching and Drypoint

The mulitplicity of technical and chemical processes employed in recent times makes it difficult to draw a sharp dividing line between original prints and reproductions. Sometimes prints by famous artists are offered for sale as if they were original graphic art, whereas in fact they are printed by industrial reproduction methods.

A truly original print is one which the artist conceives, makes, and prints himself, appending his signature to each impression. This is the method Borne has used for more than fifty years. His oeuvre is subtle and spontaneous, as he works directly on the copper plate without preliminary sketches. The versatility and skillful execution of his prints, in addition to the inherent esthetic quality of his work, make him a master of drypoint.

Like Rembrandt, the great master of etching, Borne came to realize the remarkable quality and liquid purity of surface tones which can be gained by leaving ink on the surface of the plate when printing. The variety of effects this method produces can only be achieved when the artist prints his own plates. The printing of a drypoint is as much a part of the creative process as the cutting of the plate. The word "imp" following Borne's signature on his etchings and drypoints indicates that he (and not a commercial printer) has printed his plates.

Though sometimes spoken of as etching, drypoint is in reality no such thing. Its technique and quality are very different. The burr, a rough ridge thrown up at the edge of each drypoint line by the cutting tool, catches and retains the printing ink in a special way, which bestows the line with a rich, velvety quality. This is a distinctive characteristic of drypoint. In etching there is no burr, for it is acid (usually nitric acid), and not the hand of the artist, that bites the lines into the metal plate.

In drypoint, it is generally expedient to retain the burr where a dark, velvety effect is required, while removing the burr completely or partially in areas where a delicate quality is desired. No other intaglio technique can surpass drypoint in the production of a scale of values, from rich black to fine silvery lines in lighter areas.

The drypoint technique depends for its success on a greater amount of spontaneity and sureness than any other medium in the graphic field. Because corrections on the copper plate are difficult, drypoint can be successful only in the hands of an artist who has developed great skill in addition to his inherent esthetic sensibility. Because of the fragility of the burr, the number of impressions that can be produced is severely curtailed, thus placing the drypoint in the category of a collector's item. Drypoints at their best are printed on handmade papers of suitable texture, receptivity and surface.

In etching, the strength of line and tone produced by a combination of lines is controlled by the mordant (nitric acid); contrasts in depth depend upon the length of time that some lines are permitted to bite in relation to other lines. The action of the acid can never be completely controlled by the artist, and unexpected results may occur because of the erratic behavior of the mordant. In drypoint, on the other hand, the strength of line and variations in depth are fully determined by the hand of the artist. The drypoint print, therefore, is less the result of accident and more the product of controlled self-expression. For these reasons, although Borne has created a number of successful etchings, he prefers the drypoint technique.

Drypoints and Etchings

Rainy Night, New York
Drypoint 10 x 7 inches 1939

This drypoint was executed directly on copper from a window of the artist's studio on 79th Street, between Columbus Avenue and Broadway, on a dark, rainy night. The artist was intrigued by the play of light on wet sidewalks, which changed houses and cars into deep shadowy forms.
 This drypoint was awarded the Talcott Prize at the American Society of Etchers Annual Exhibition in 1939.

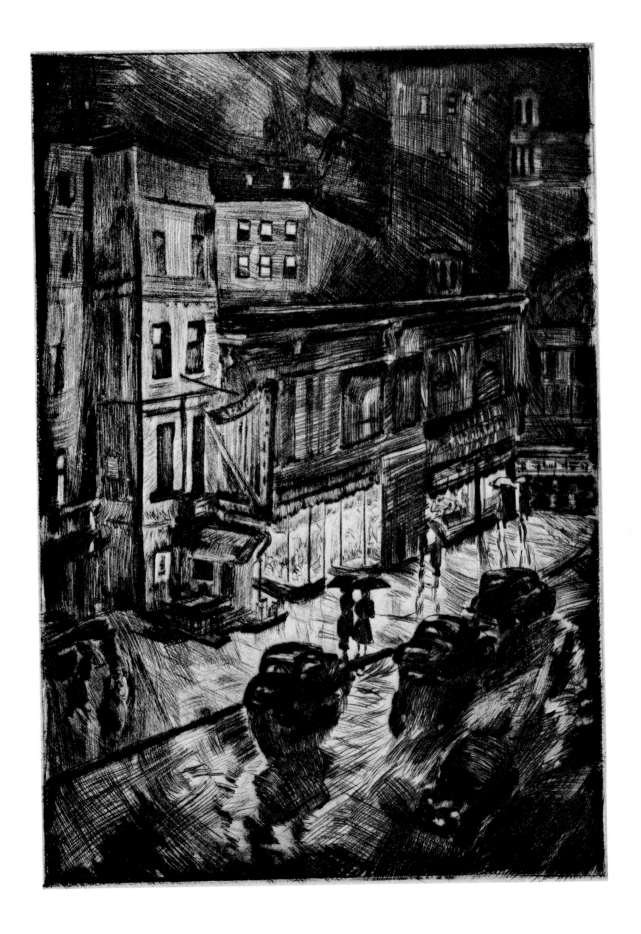

City Hall with Civic Virtue
Drypoint 10 x 7 inches 1932

The sculpture Civic Virtue, *created in 1919 by Frederick MacMonnies, was removed from view for many years because feminist organizations objected to the depiction of a nude male figure trampling females under his feet. Now the sculpture is on public display again at Queens Boulevard in Kew Gardens.*

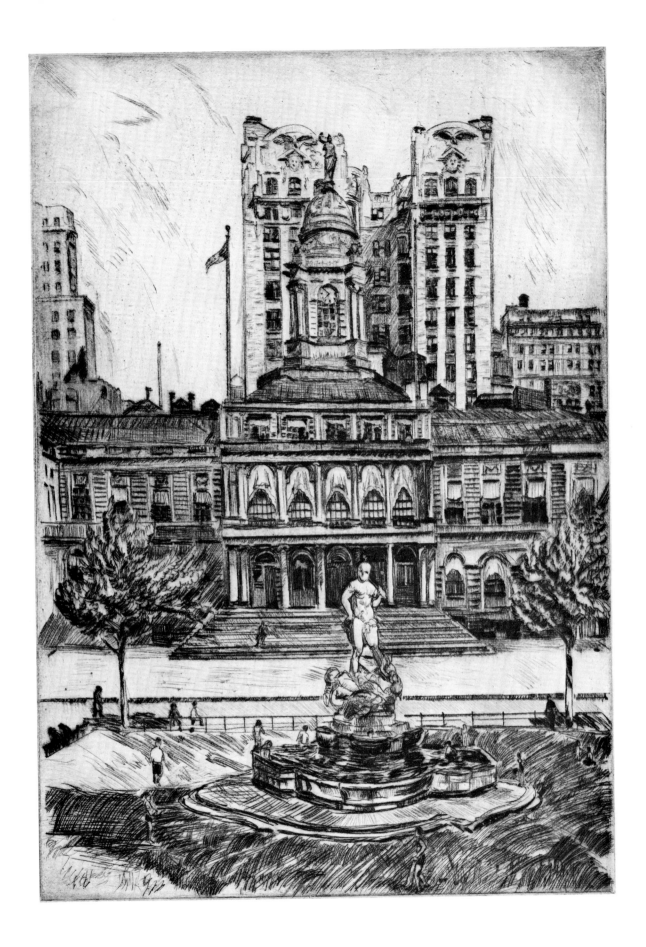

Plaza Towers, New York
Drypoint 10 x 7 inches 1930

Grand Army Plaza, frequently referred to as "The Plaza" (58th to 60th Street), provides a formalized entrance to Central Park and is surrounded by buildings remarkable for their architectural unity. The buildings depicted in this drypoint, viewed from Central Park, include the Sherry-Netherlands Hotel, the Savoy-Plaza Hotel, and the Hotel Pierre, all on the east side of Fifth Avenue.

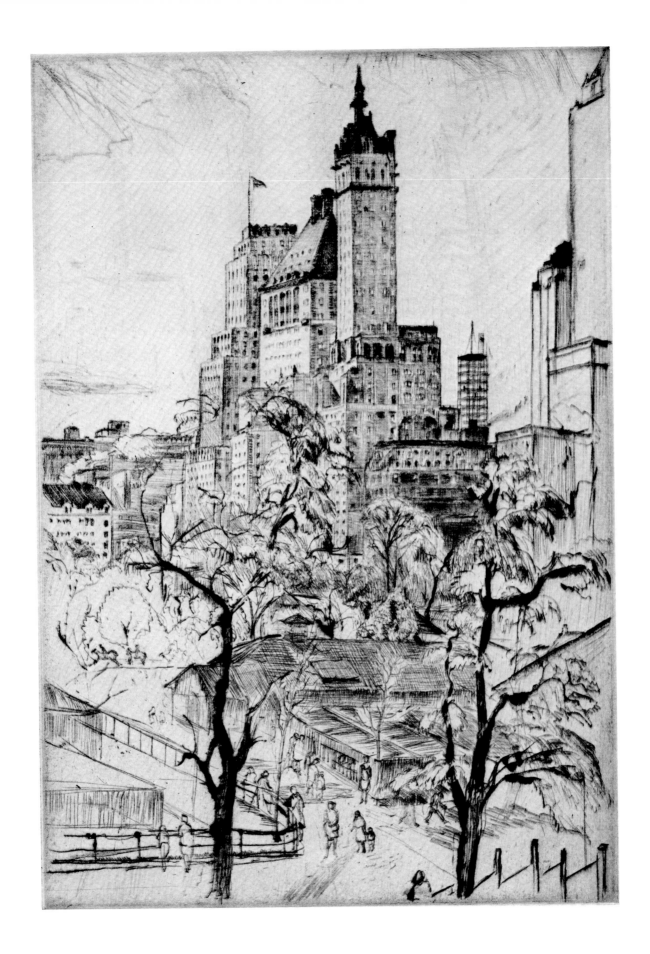

Demolition of Sixth Avenue "L" at 14th Street
Drypoint 8 x 11 inches 1940

In 1875 New York City authorized the construction of the Sixth Avenue elevated lines. Even though transportation was efficient and commuters on the "L" were fascinated on their journeys by fantastic scenes of glittering rivers, skyscrapers at dusk, and miniature streets, the "L" was demolished because its gaunt trestle-work brought twilight to miles of streets and lowered real estate values.

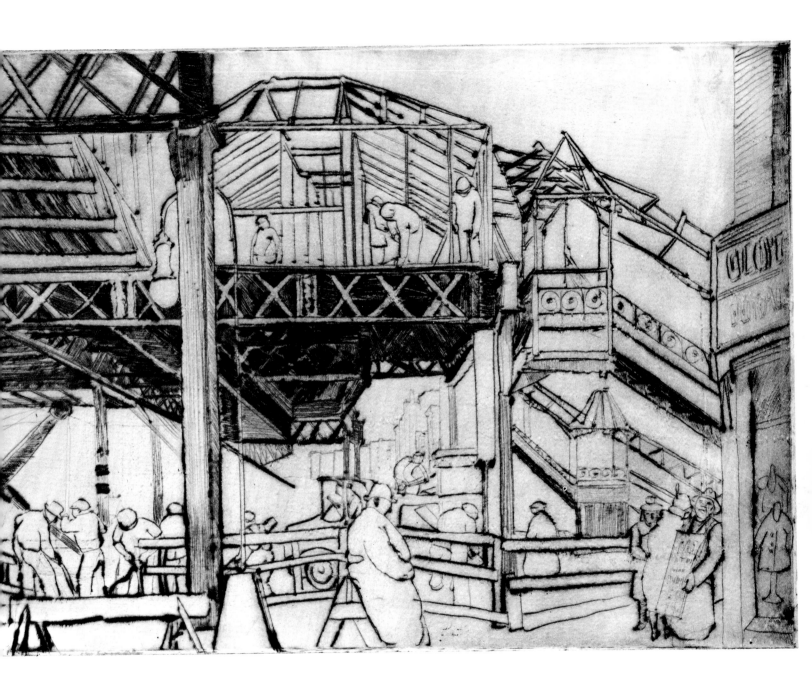

Church at 79th Street and Broadway
Drypoint 9 x 7 inches 1937

The First Baptist Church, erected in 1891-2, is referred to as the "Mother of Churches" by the Baptists, because of its role in helping to found other churches of this denomination in America. The congregation originated in 1728, in group meetings of the Baptists. Their first church was built in 1745.

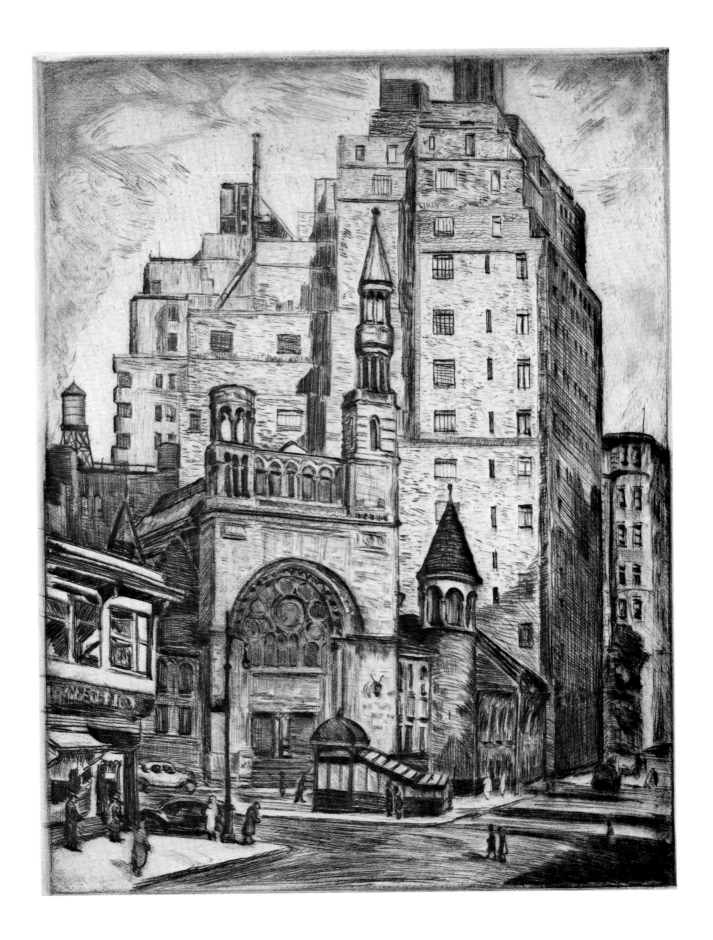

Stock Exchange from Subway Station
Drypoint 10 x 8 inches 1931

*The New York Stock Exchange, now located at 11 Wall Street, was estab-
lished as early as 1790, shortly after the formation of the United States. It
helped to finance the Civil War.*

*There is no quieter place than the financial district on a Sunday, and thus
it was one of the artist's favorite working places. To make this print, the ar-
tist placed himself alongside the Independent Subway station looking south-
west, and worked directly on his copper plate.*

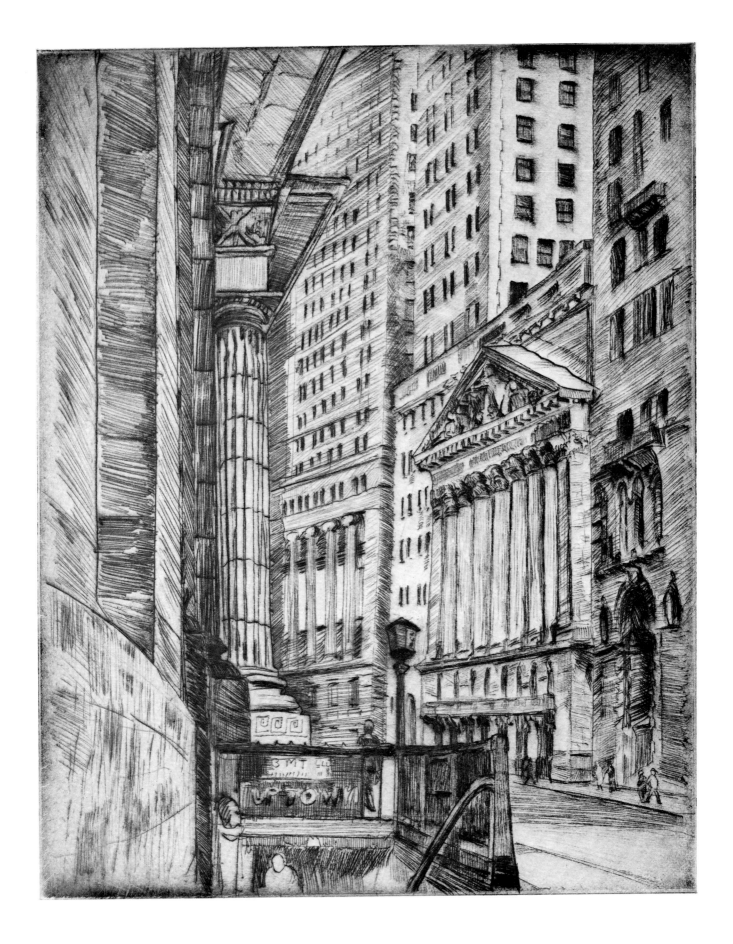

Manhattan from Brooklyn
Drypoint 7 x 10 inches 1933

At the foot of Fulton Street in the Borough Hall section of Brooklyn, the artist found that he could contemplate the Manhattan skyline undisturbed. He noted the surprising fact that buildings of various forms and sizes, fortuitously placed, present a harmonious mosaic pattern when viewed from across the East River.

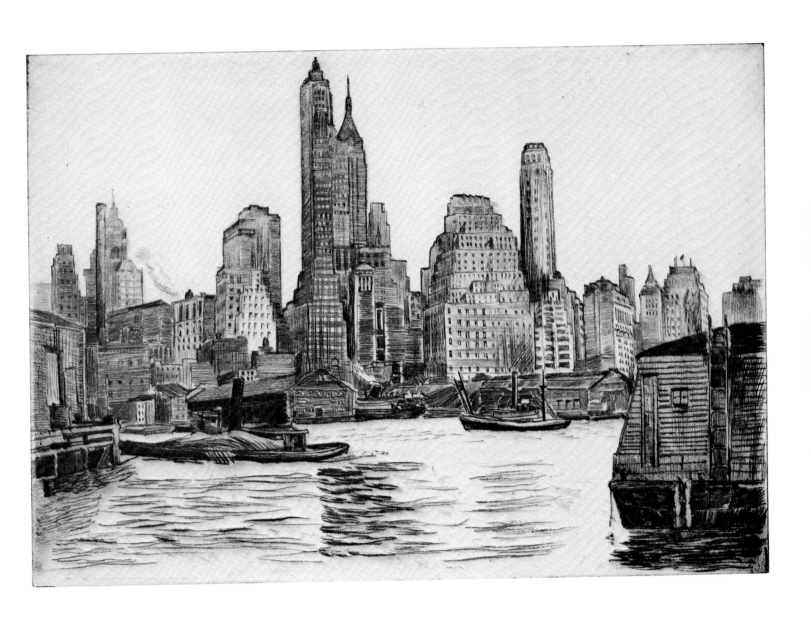

Columbus Circle (small)
Drypoint 7 x 8¼ inches 1938

At the center of Columbus Circle (Broadway at 59th Street) stands a seventy-seven foot granite column supporting a marble statue of Christopher Columbus, completed by Gaetano Russo in 1894.
* Like all the others, this plate was cut directly from nature, so that the print is a mirror image of the actual scene.*

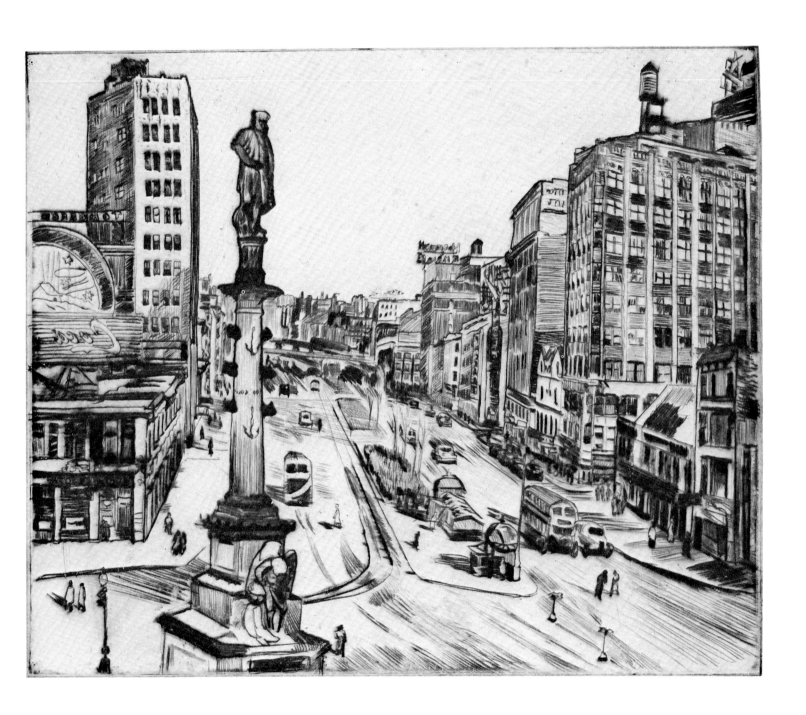

Union Square (large)
Drypoint 10 x 8 inches 1932

*The Union Square section extends from 14th Street on the south to 18th
Street on the north, and from Third Avenue east to Sixth Avenue west.*
 *This drypoint was made on a sunny day from the artist's studio on the
east side of the square.*

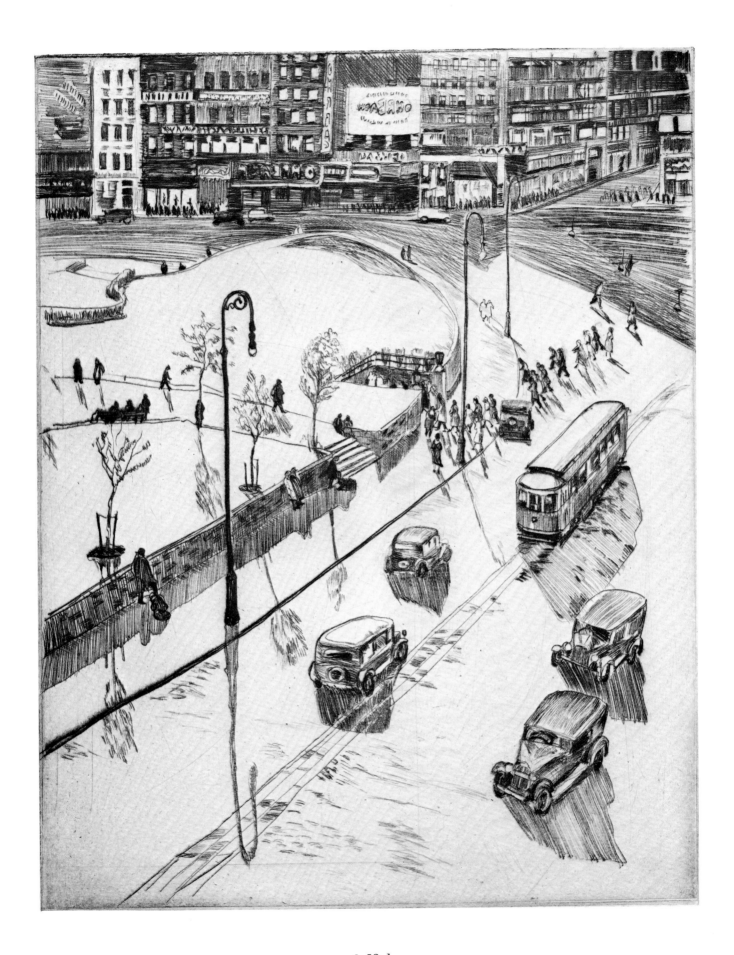

Broadway from Trans-Lux Building
Drypoint 10 x 8 inches 1939

The jostling crowds on Broadway in the Times Square district made it very difficult to work directly on a copper plate. The artist took refuge on a floor of the Trans-Lux Building where, from a window, he was able to depict this spectacular view.

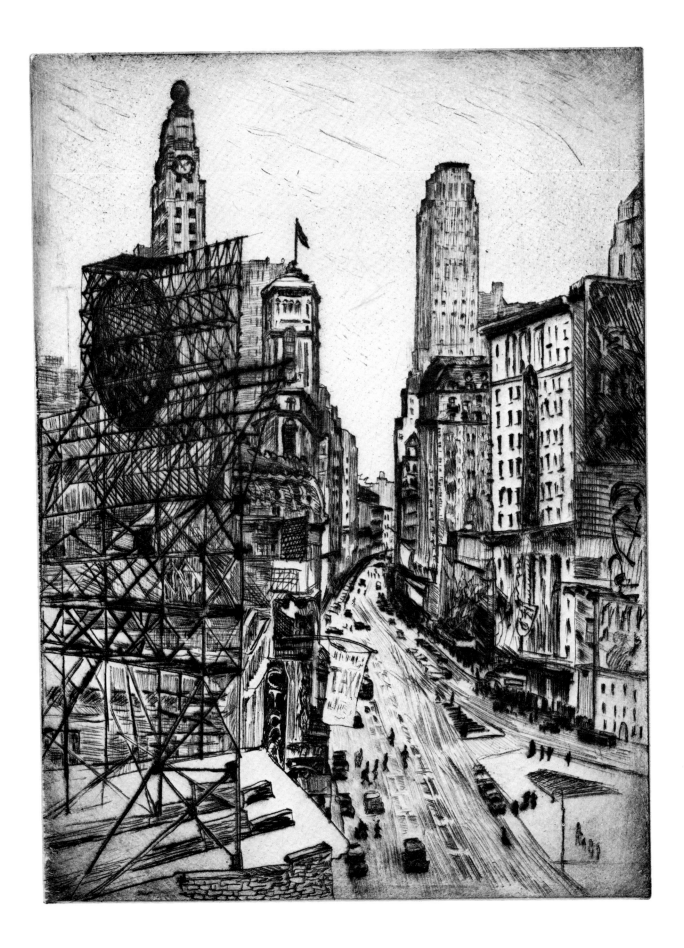

Coal Barges at Dusk, Sheepshead Bay
Drypoint 8 x 10 inches 1939

At dusk, the functional details of barges on the water disappear and the bare structures take on a homogeneous character. When the barges are seen against a pristine sky, they offer a powerful display of chiaroscuro.

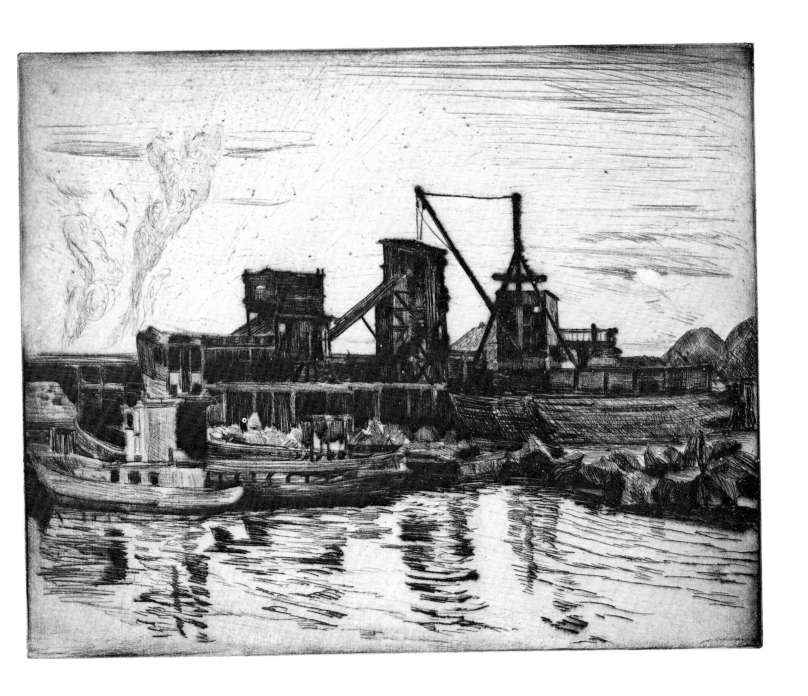

Columbus Circle with Sunkist Billboard
Drypoint 10 x 8 inches 1937

As usual, the artist worked directly on the copper plate, without a prelimi-
nary sketch, in order to achieve the maximum effects of spontaneity. He
worked from a window on the south side of Columbus Circle. In the print,
the traffic moves on the left because cutting directly on the plate results in a
mirror image. This also accounts for "Sunkist", seen in reverse.

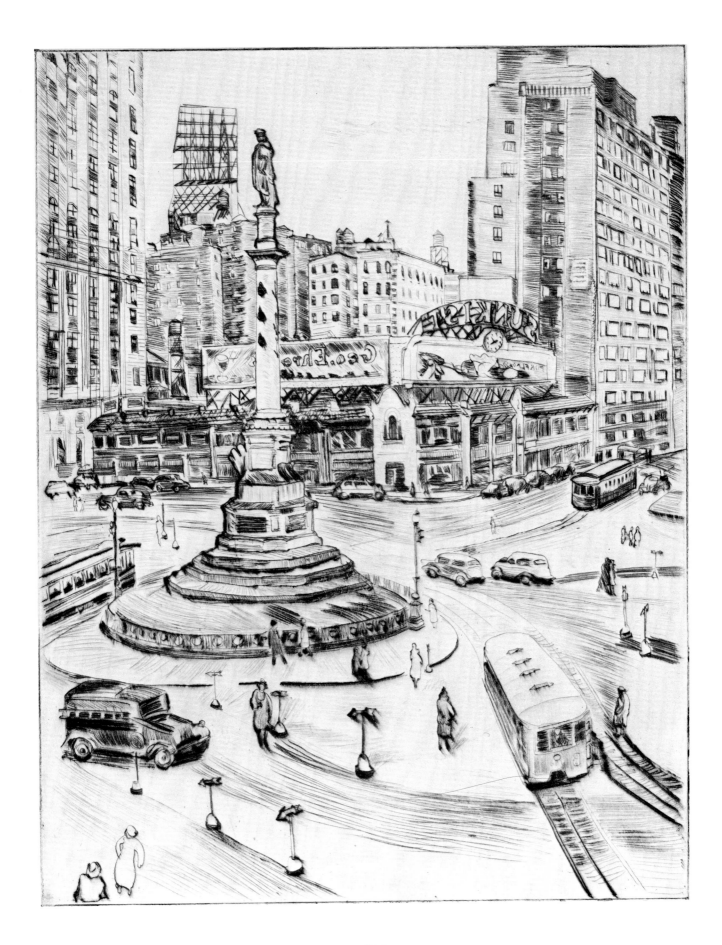

East Fulton Street "L"
Drypoint 8 x 5½ inches 1929

Downtown Manhattan had many quaint streets paved with large cobble-stones and shadowed by elevated structures. This print shows a view of Fulton Street on the East Side, with the elevated lines and automobiles of the 1920s.

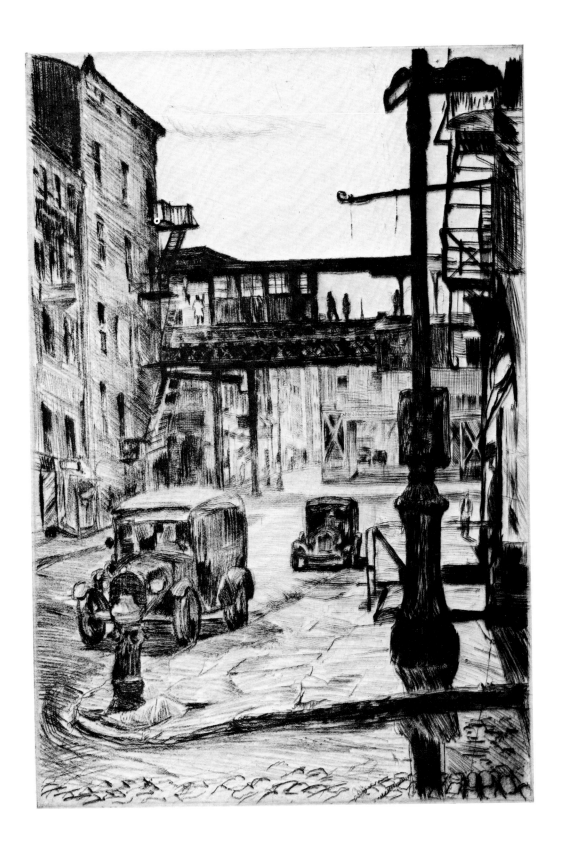

Lower Manhattan Skyline
Drypoint 7 x 10 inches 1940

This is the artist's favorite view of Manhattan, as seen from across the East River at the foot of Fulton Street in Brooklyn Heights, a short distance from the Brooklyn Bridge.

Lower Manhattan covers an area extending from the East River to the Hudson River and includes the Wall Street district, the City Hall district, Chinatown, the Lower East Side, and Greenwich Village. It is the oldest section of the city and the richest in historical associations. Skyscrapers multiplied rapidly after the turn of the century and Lower Manhattan became a commerical, financial and industrial center.

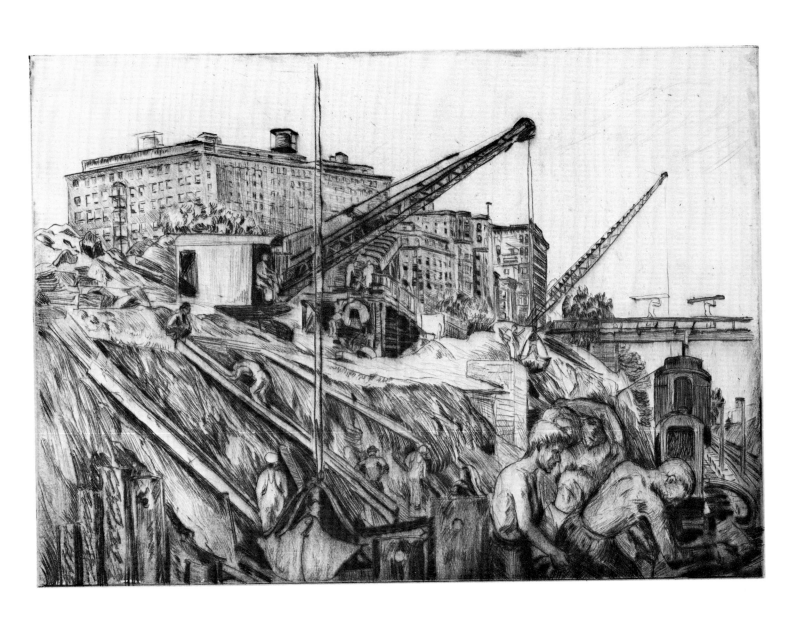

Gossips on State Street, Brooklyn Heights
Drypoint 10 x 7 inches 1949

The scene is State Street, Brooklyn Heights, on a hot summer day in 1949, directly across from the artist's studio. On this day, people stayed outdoors, taking refuge from the intense heat of their living quarters. They did all their socializing in the open air.

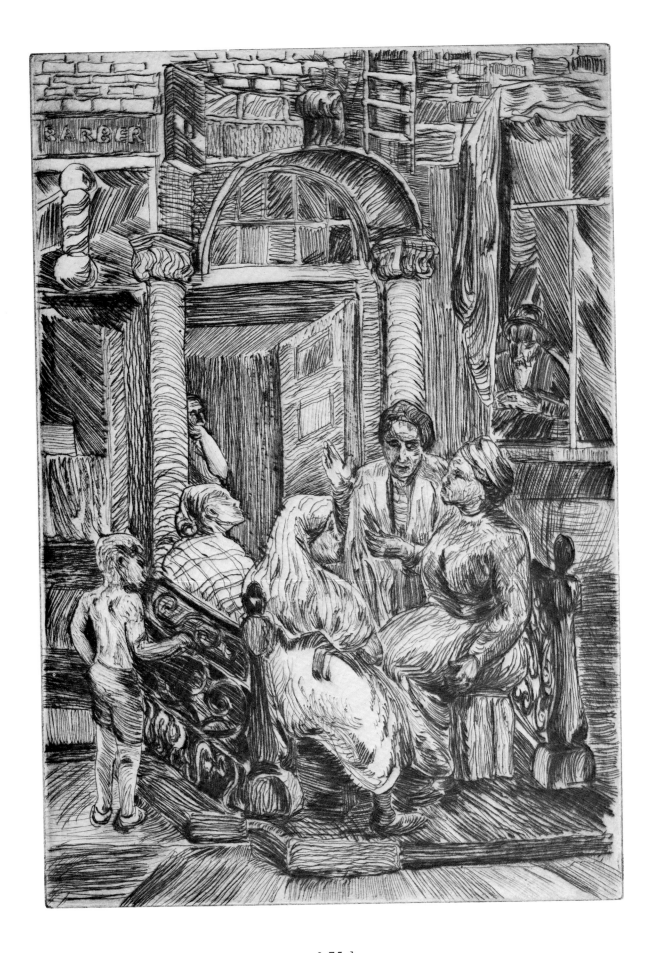

Little Bridge, Central Park
Drypoint 6 x 8 inches 1934

Among the charms of Central Park, which stretches two and a half miles from 59th Street to 110th Street in Manhattan, are the little bridges that span the ponds and brooks. Each bridge was individually designed by Calvert Vaux around 1858.

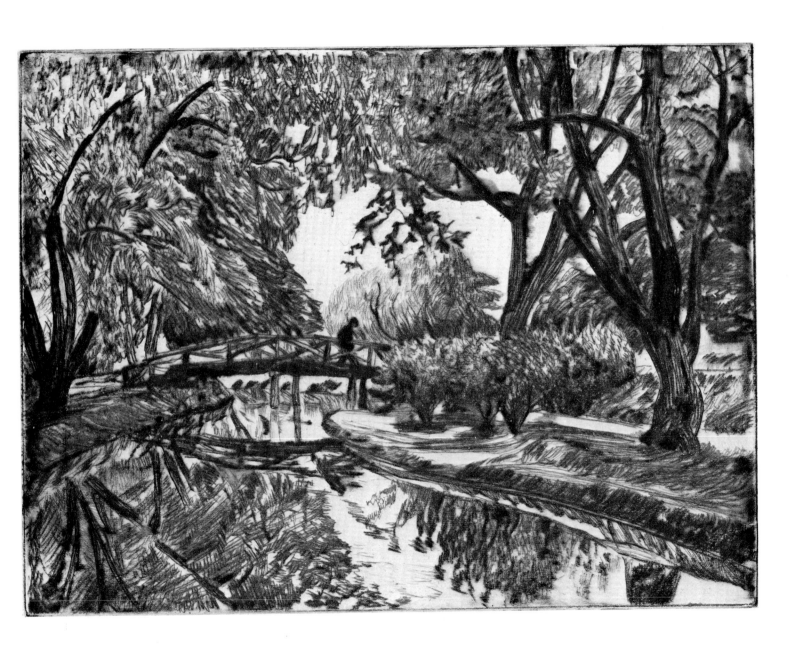

Times Square
Drypoint 8 x 6 inches 1937

The artist stationed himself near Father Duffy's statue, on a little concrete sidewalk which serves as a refuge for people crossing the wide and busy Times Square. Facing south, he worked directly on the copper plate. Crowds stopped to watch but had to move on as more and more people gathered.

Some of the buildings which were the focus of this composition have since made way for other structures.

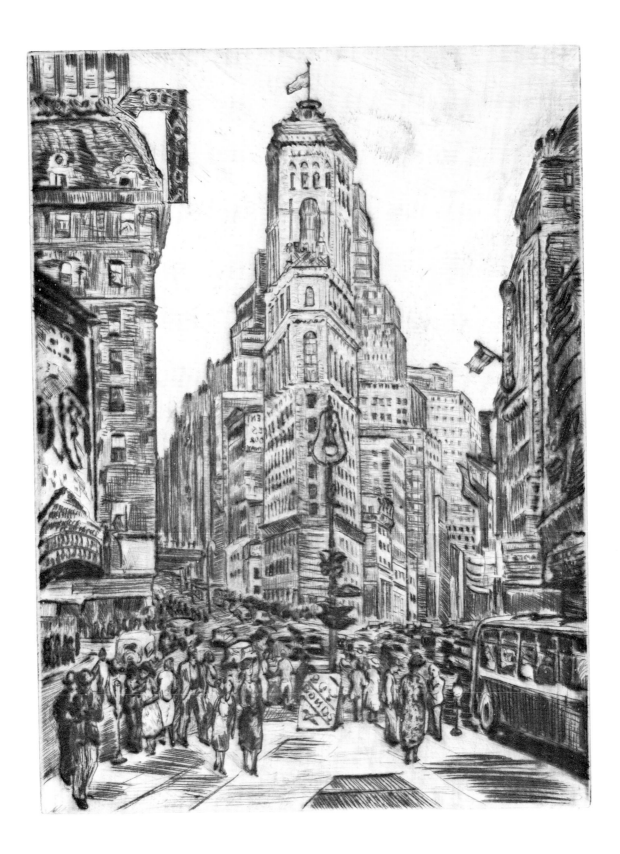

Landscape, Site of World's Fair
Drypoint 12 x 15 inches 1938

*The New York World's Fair of 1939 took place in Flushing Meadow Park,
between Northern Boulevard and Grand Central Parkway in the borough of
Queens, about eight miles from Times Square. The site covered more than
a thousand acres, nearly two square miles.*

*Plans for the Fair were made in 1935. New highways and bridges, and
major improvements made for the 1939 World's Fair, transformed the North
Shore, most of which had remained unchanged for years.*

*This drypoint won the Noyes Prize for best print at the American Society
of Etchers 28th Annual Exhibition.*

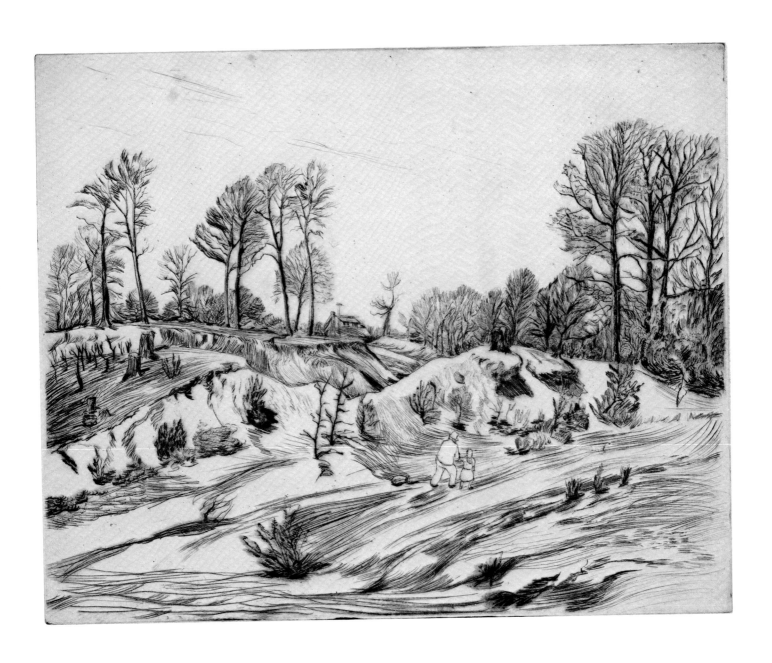

Central Synagogue
Drypoint 8 x 6 inches 1931

Located at 652 Lexington Avenue at 55th Street, this synagogue has been used continuously for services since the early 1870s. Its Moorish Revival style contrasts boldly with the character of the buildings around it.

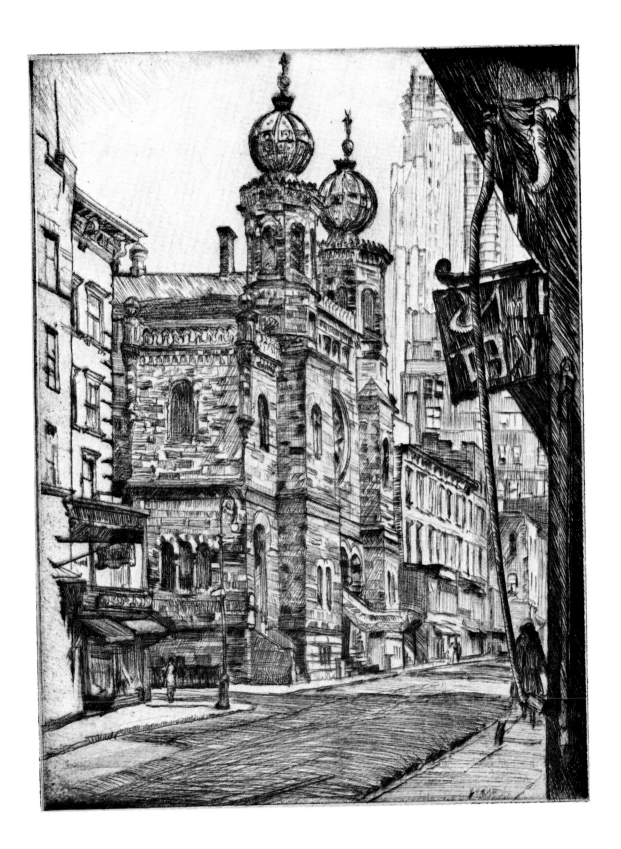

Dyckman House
Drypoint 8 x 10 inches 1931

When the artist made this plate, he was unaware of the historical character of Dyckman House, which stands on Broadway at 204th Street in New York. He was primarily attracted to the landscape. Years later he learned that Dyckman House, built in 1783, was a museum of Dutch and English Colonial furniture and curios.

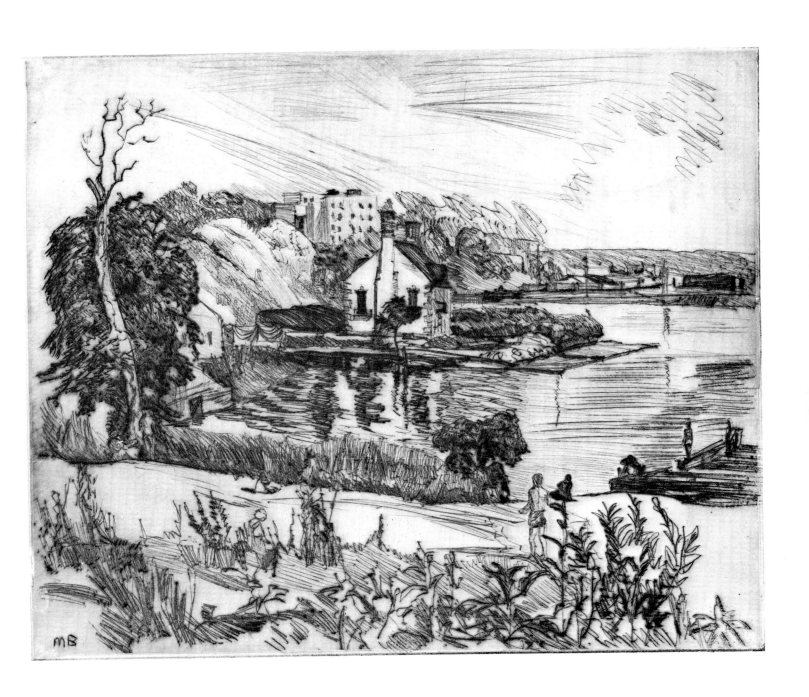

May Day, Union Square
Drypoint 8 x 6 inches 1931

Union Square has been a meeting place for mass protests from the time of the Civil War. On March 6th, 1930, more than 35,000 unemployed workers and sympathizers gathered in Union Square to protest the widespread unemployment that followed the financial crisis of October, 1929. Subsequently, the assembly in Union Square and a May Day Parade became annual events.

From his studio window on 17th Street and Union Square, the artist watched the huge crowd on May Day. It was a challenge for him to record the scene directly on a copper plate, and reduce the mass of individual figures to a simple linear contour.

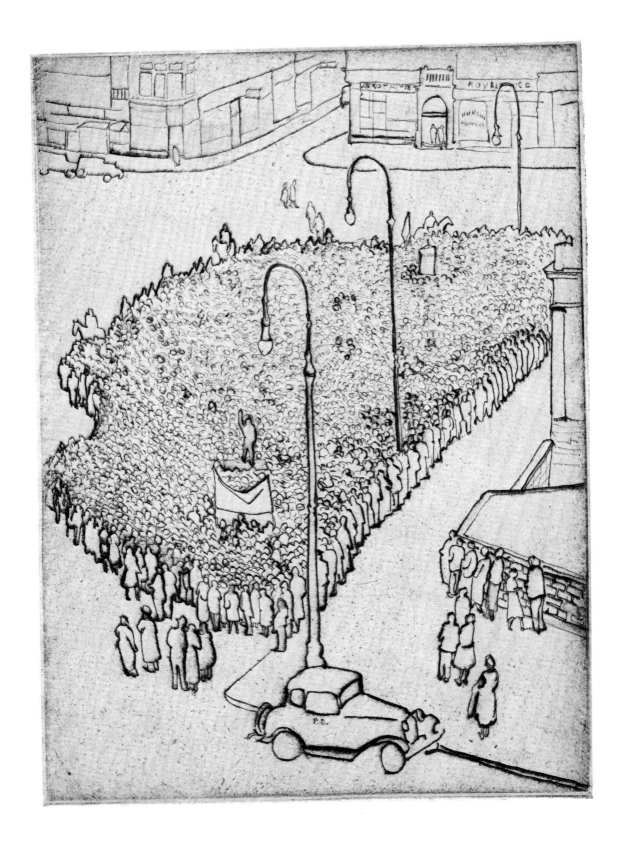

Skaters, Central Park (large)
Drypoint 12 x 15 inches 1934

This skating rink was opened in Central Park in 1859 and has been a source of pleasure for New Yorkers ever since.
 One cold winter day, the artist braved the elements and sat outdoors to cut this plate.

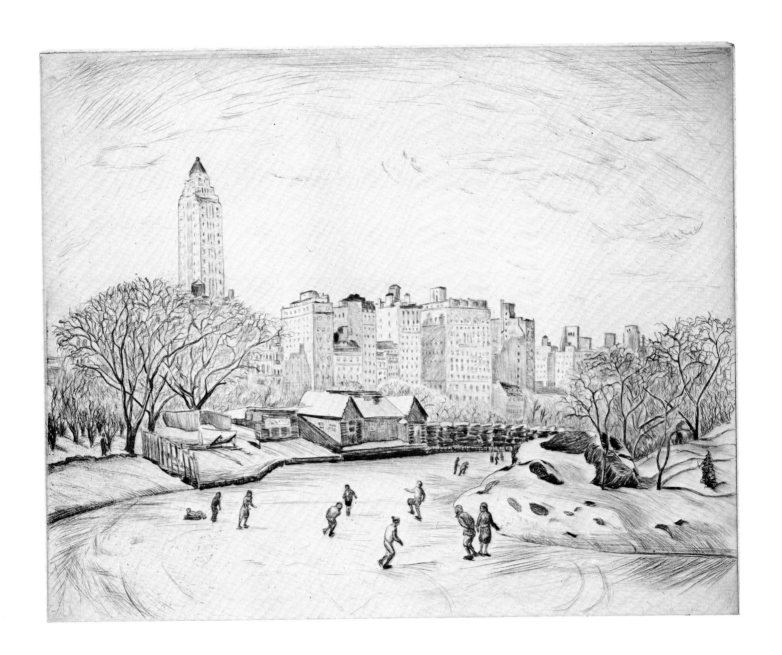

View of Central Park, Winter
Drypoint 12 x 15 inches 1933

Central Park is famous for taking the New York City dweller out of his urban surroundings. This panoramic view of Central Park as seen from a window of the American Museum of Natural History eludes description. Instead of an objective view of the landscape, we are given the artist's subjective vision, which dislodges us from being mere observers, and sweeps us into its own space.

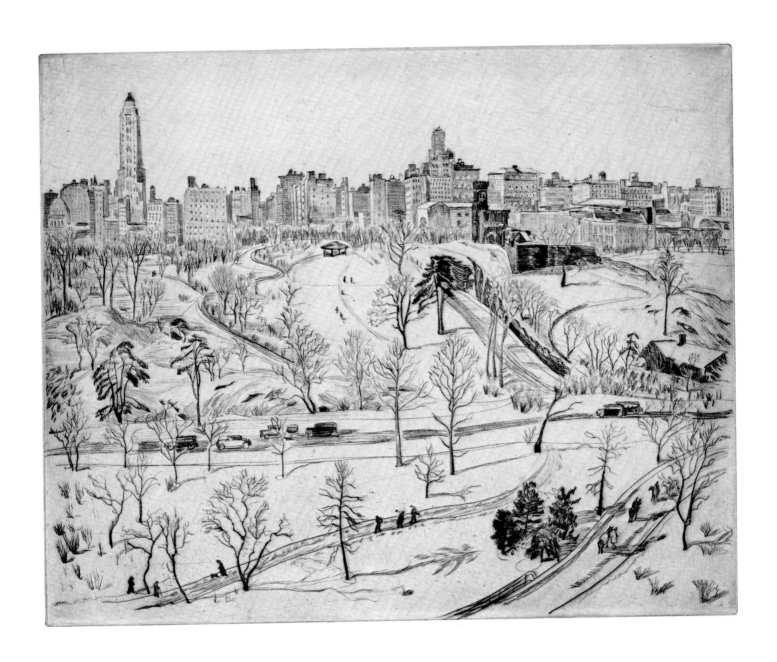

Skaters, Central Park, Looking West
Drypoint 9 x 7 inches 1934

Central Park is a busy place in the winter as well as in the summer. Looking west across the frozen lake in the park, with Central Park West in the distance, the artist was fascinated by the figures of the young skaters skimming over the ice.

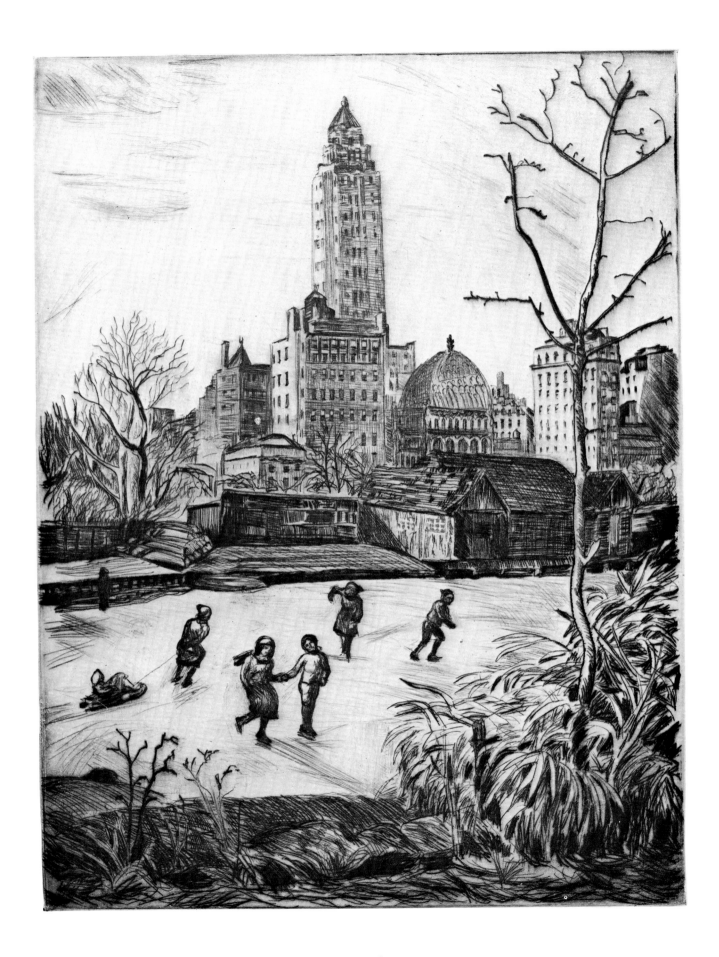

Riverside Drive, Winter
Drypoint 7 x 9 inches 1932

Riverside Drive extends from 73rd Street to Dyckman Street, and borders the Hudson River. Building of the Drive began in 1885, and it was opened in 1901. In 1909, Japanese residents of New York City made a gift of 2,100 cherry trees, which were planted along the roadway.

The vista depicted here is from 74th Street to 92nd Street, on a winter day. In the artist's desire to produce a spontaneously created drypoint, he endured the cold to work outdoors on his copper plate.

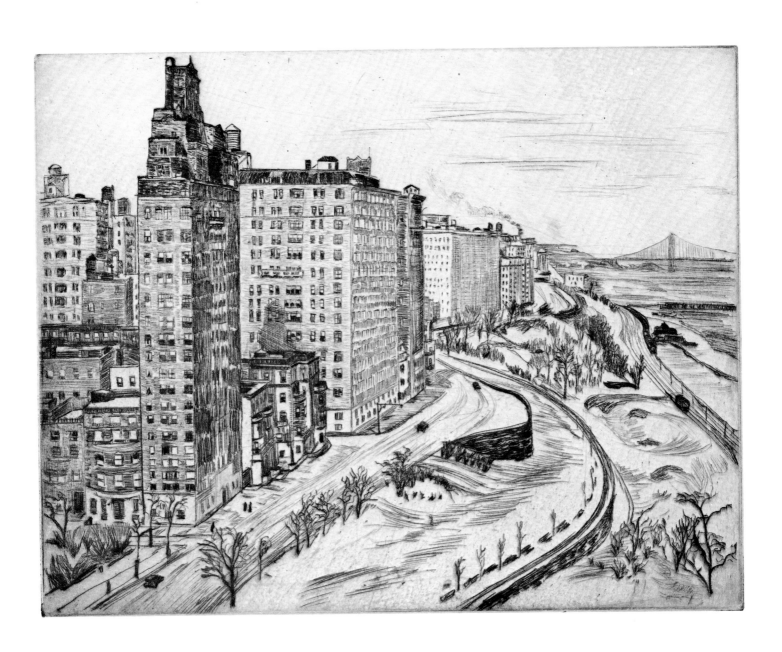

Bronx Street
Drypoint 11¾ x 9 inches 1937

*Wandering about the streets of the Bronx, with a folding stool under his arm
and his specially constructed box containing a copper plate and diamond-
pointed needle, the artist found himself on a concrete parapet above a
typical Bronx street. He was fascinated by the forms of the shadows.*

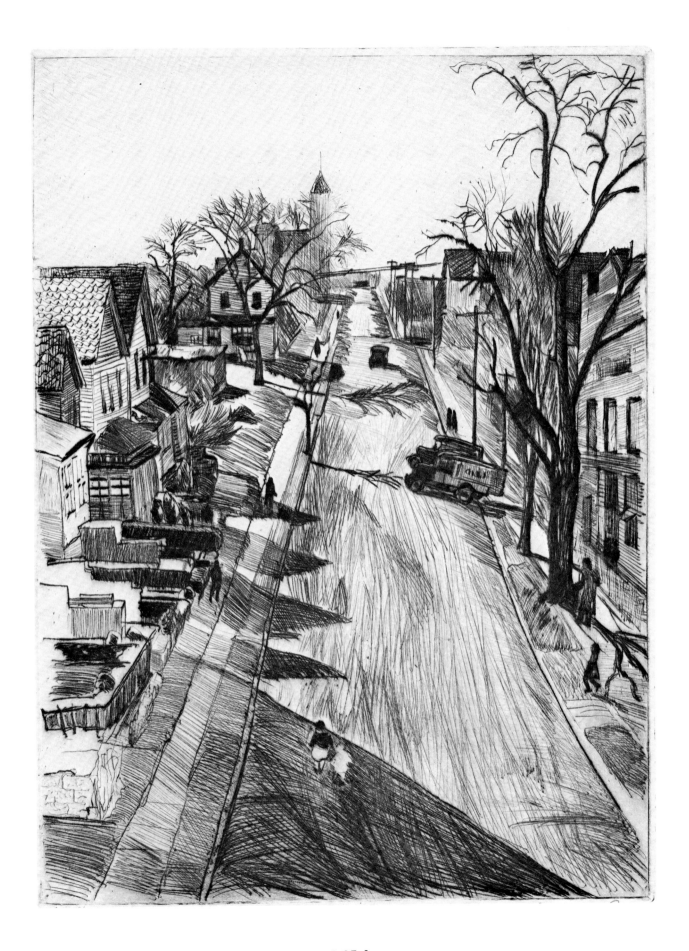

Columbus Circle, Erection of Skyscraper
Drypoint 12 x 10 inches 1940

The artist came upon a building under construction on the corner of Seventh Avenue and 59th Street. The steel structure seemed to form a monistic whole. He chose the appropriate forms and disregarded what did not conform to his esthetic point of view.

When completed, the structure became a high-rise residential building which is still standing today.

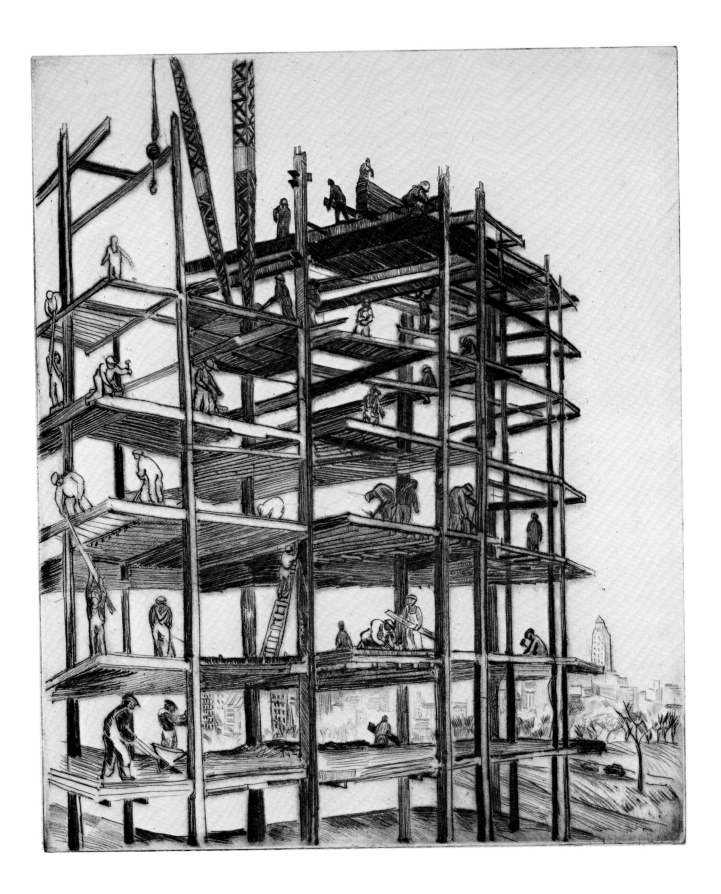

Tugboats, Wall Street
Drypoint 8 x 6 inches 1939

New York has nearly seven hundred miles of water frontage. From the end of Manhattan to the open sea is only about seven miles, and oceangoing vessels drawn slowly by tugboats through New York Bay are usually at full power an hour after leaving the pier.

From time to time one can spy the strongly built tugboats at Wall Street, helping large vessels into and out of port. Barges, dredging and salvage equipment, and disabled ships are also aided by tugboats.

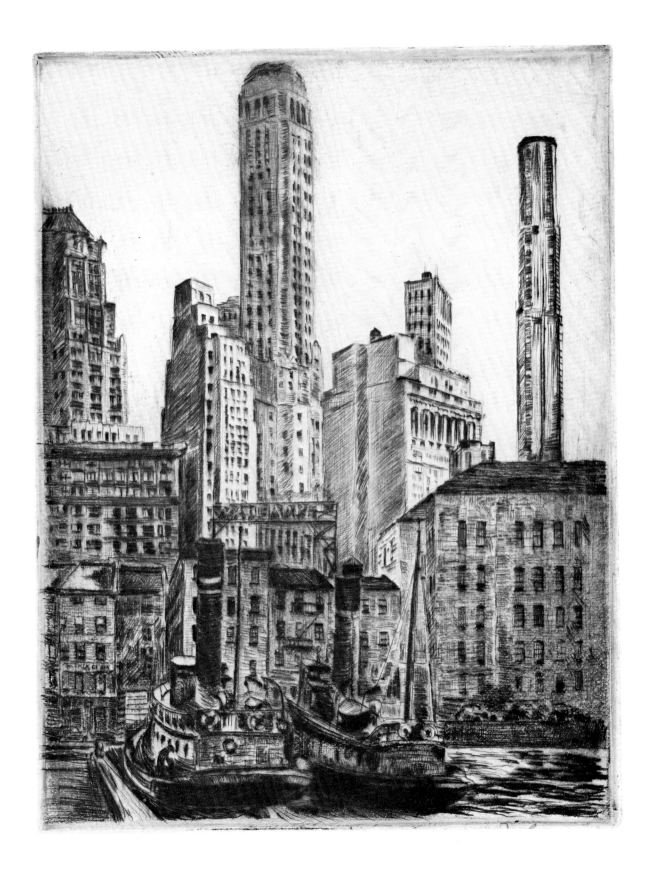

Indian Hall, Museum of Natural History, New York
Drypoint 10 x 8 inches 1934

*The American Museum of Natural History in New York City, built in 1869,
is located at Central Park West, between 77th and 81st Streets. It is one of
the world's largest institutions devoted to natural science exhibits. It is also
noted for the quality of its ethnological material, particularly pertaining to
the North American Indians.*

*The artist, fascinated by the American Indian Hall, was a frequent visitor
and made a number of drypoint prints, of which this is one example.*

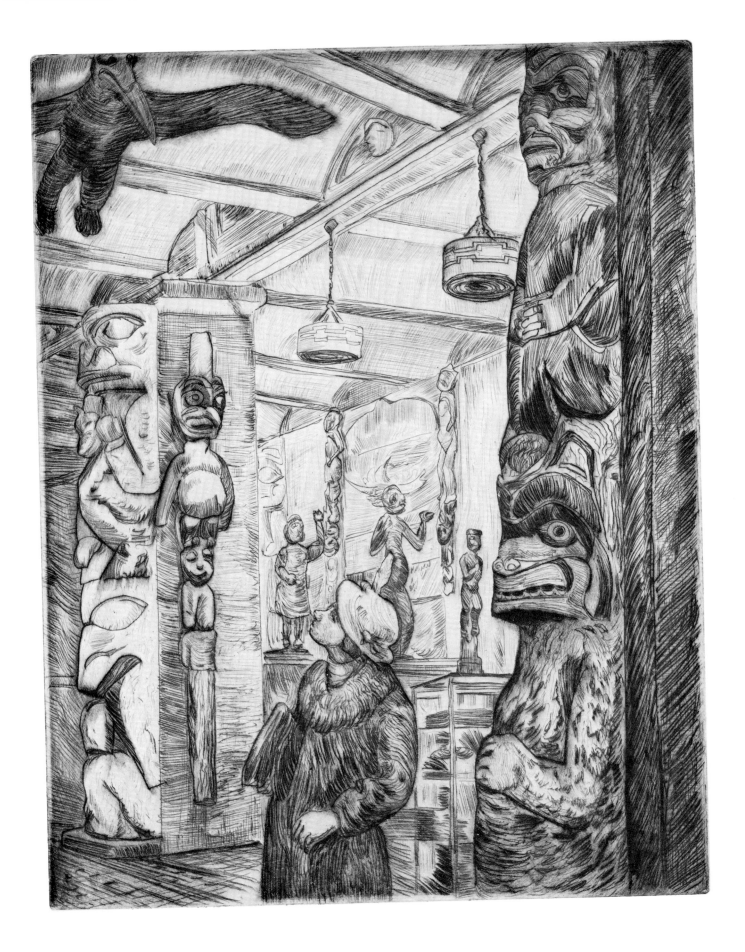

Union Square, Panoramic View
Drypoint 8 x 10 inches 1932

The artist cut this plate while sitting at the window of a building on the west side of the Square. Focusing on the Consolidated Gas building, he captured the spirit of this breathtaking view.

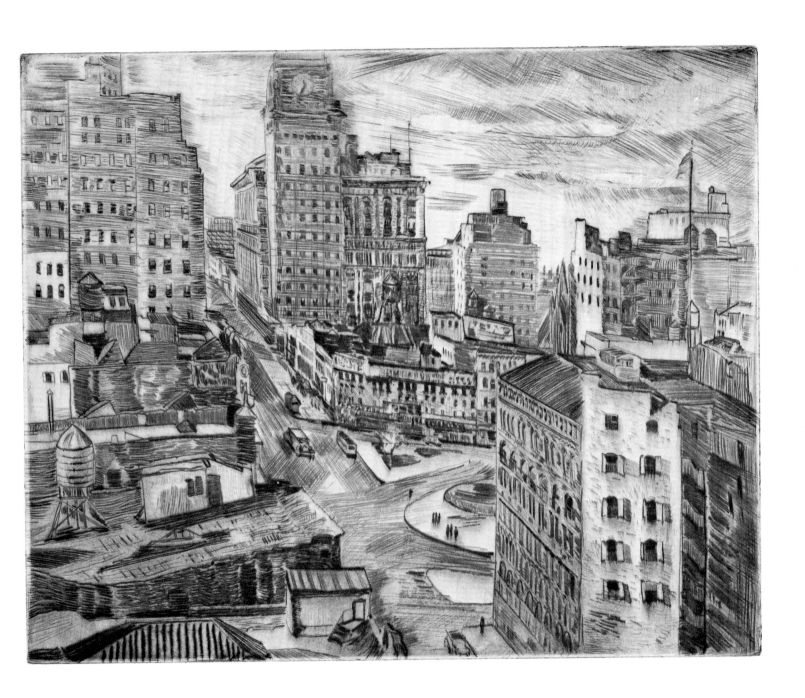

Chinatown, Doyers Street, New York
Drypoint 7 x 10 inches 1940

Working on the copper plate while sitting on the sidewalk of Doyers Street,
the artist merged his ethos with the ethos of Chinatown.
 Early Chinese settlers on Doyers Street transformed a rundown tenement
district into a colorful ethnic quarter. The young Irving Berlin occasionally
performed as a singing waiter at number 6 Doyers Street, the former
Chatham Club.

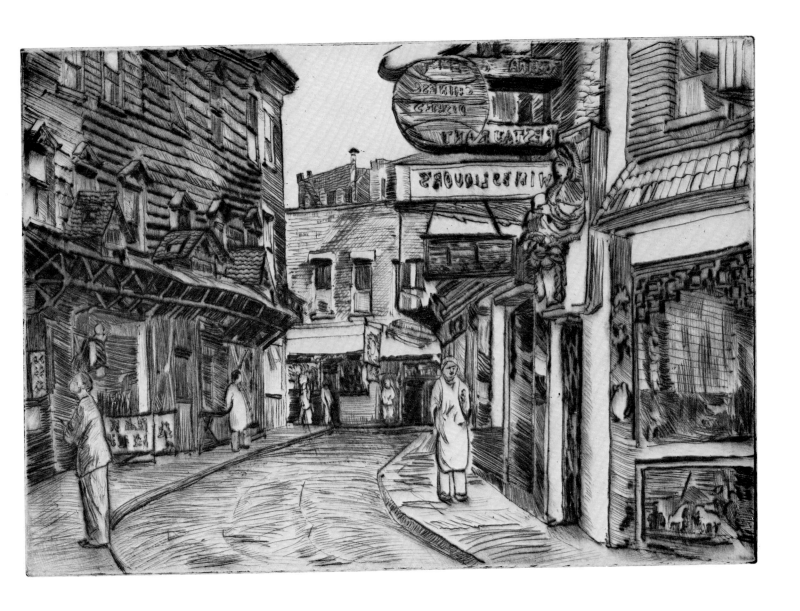

"L" Lines from Roof on East Broadway
Drypoint 8 x 6 inches 1934

There are several famous institutions on East Broadway on the Lower East Side of Manhattan, including the largest Yiddish daily newspaper in the world, the Jewish Daily Forward, founded in 1897.

The artist was primarily interested in the pattern of elevated tracks which created a fantastic view of that part of the city. He made this drypoint from one of the rooftops, where he could see the intricate web of steel rails and concrete buildings, symbolic of the great metropolis.

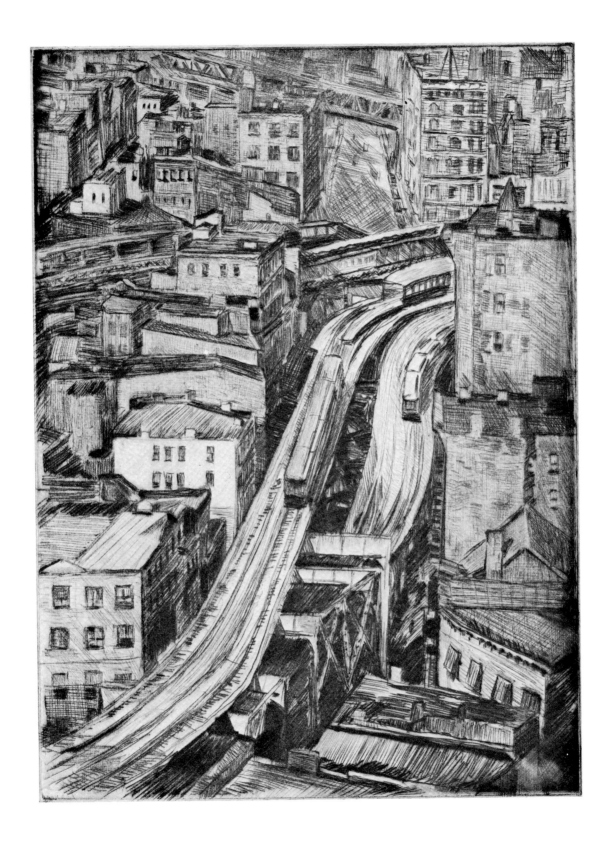

Negro Preacher
Drypoint 10 x 7 inches 1937

In 1937, the WPA Federal Negro Theatre, housed in the Lafayette Theatre on Seventh Avenue near 131st Street in Harlem, presented the play Turpentine *with an all-Negro cast.*

The artist attached a small flashlight to a board which held his copper plate, so that he could work in the darkened theatre from his perch in one of the box seats.

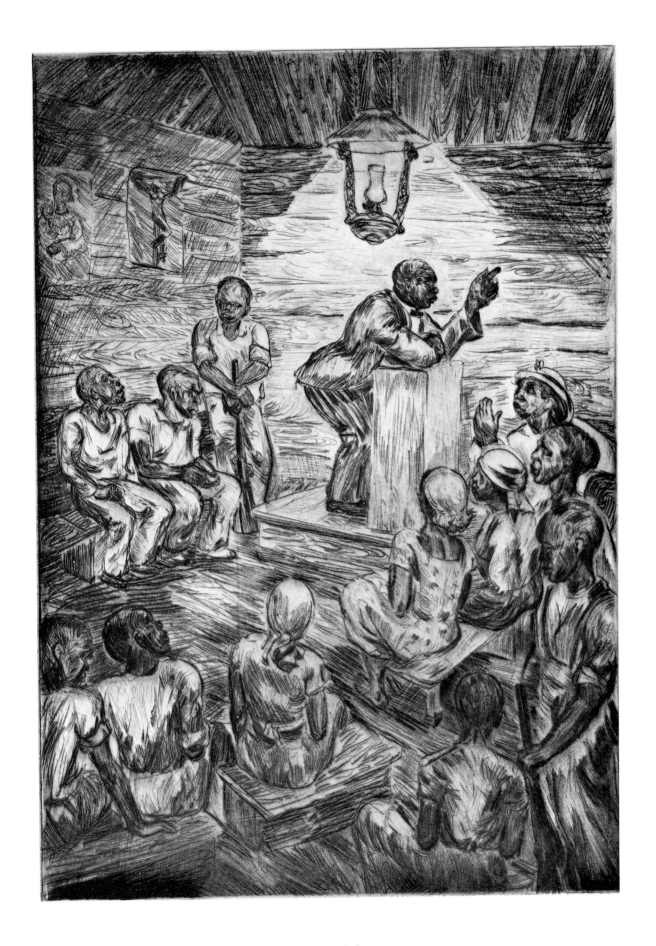

WPA Lineup at Times Square [Manhattan Episode]
Drypoint 8 x 10 inches 1938

In 1935, President F.D. Roosevelt established the Works Progress Administration (WPA) when unemployment was widespread. Altogether, the WPA employed a total of 8,500,000 people.

This scene depicts unemployed workers lined up for their benefit checks at Times Square during the Depression. In the foreground, a policeman is telephoning his superiors.

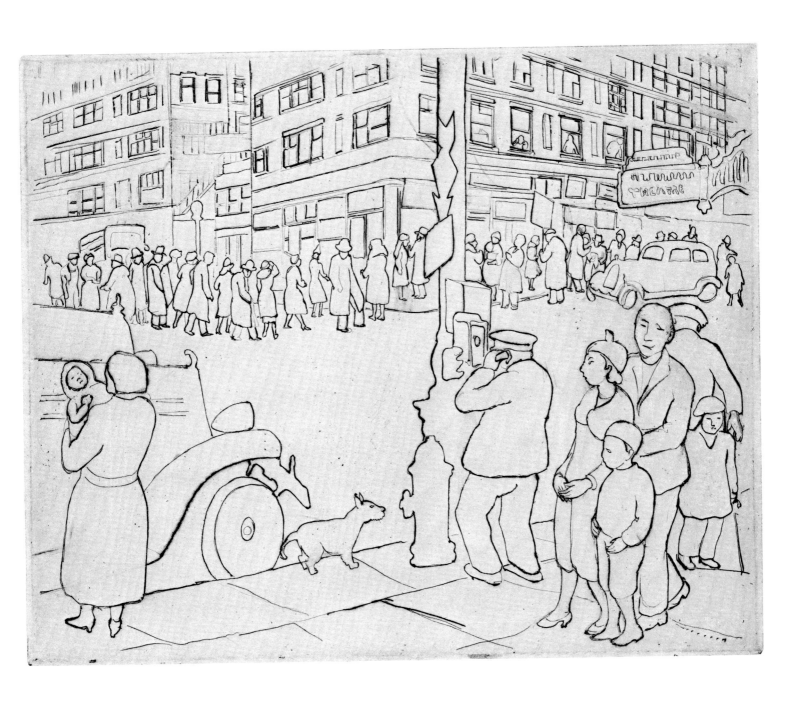

Café
Drypoint 10 x 8 inches 1933

In his desire to express reality in its most basic and direct form, the artist was drawn to places where he could observe groups of people without being noticed. Cafeterias frequently served as the artist's "studio." In this drypoint, the Horn and Hardart Automat in New York City offered the perfect setting. The interest of this simple drypoint lies in the clarity and precision of the line.

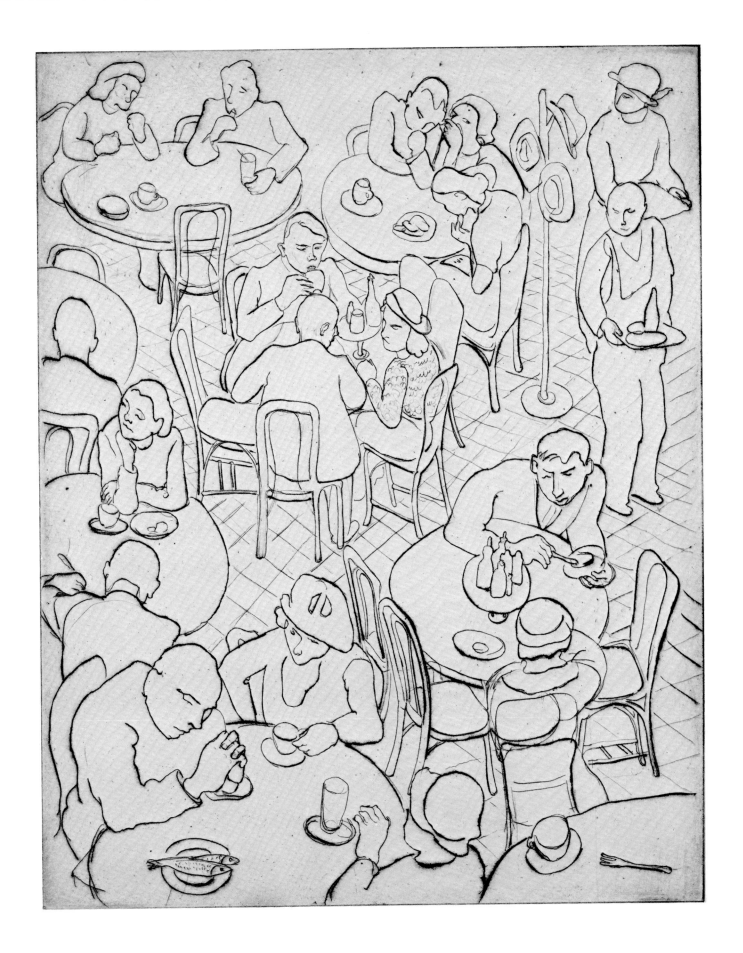

79th Street Between Broadway and Columbus
Drypoint 7 x 10 inches 1934

Some New York City streets exude a small-town nostalgia, especially in the winter. This scene, from the sidewalk in front of the artist's studio, is typical of such side streets in Manhattan's Upper West Side.

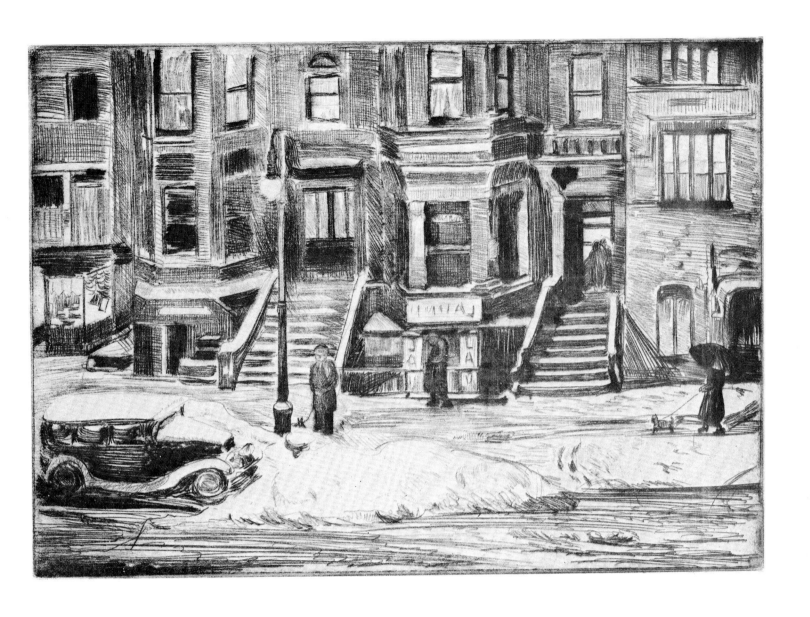

Fulton Street "L" with Beecher Monument
Drypoint 6 x 7½ inches 1949

J.Q.A. Ward's bronze statue of Henry Ward Beecher (brother of Harriet Beecher Stowe, who wrote Uncle Tom's Cabin*) was erected in Brooklyn Heights in 1891. Beecher was the first minister of Plymouth Church of the Pilgrims, and was a tireless opponent of slavery. During his ministry, Brooklyn became a center of abolitionism.*

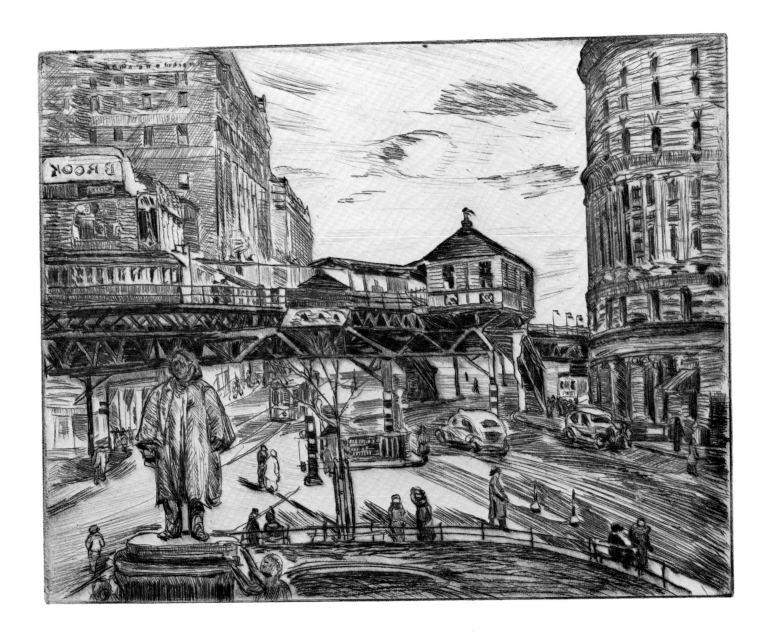

West Street at 10th Street
Drypoint 7 x 9 inches 1934

West Street extends from Battery Place to 72nd Street along the Hudson River. In Revolutionary days what is now West Street was under water.
 During the time of the WPA, it was not unusual for the U.S. government to pay unemployed workers to repair some of New York's streets. West Street at 10th Street was repaired in this way.

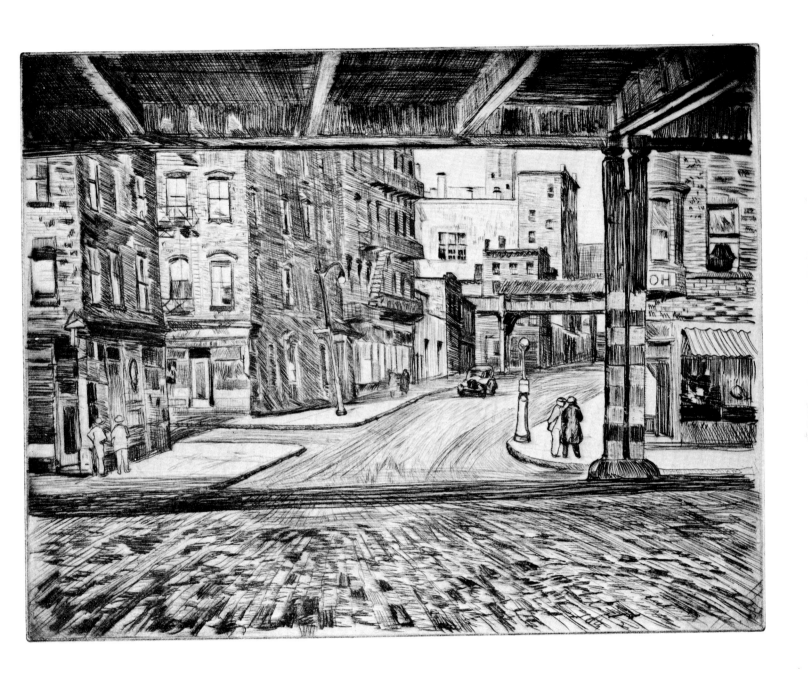

Revolving Bridge, East River
Drypoint 6 x 8 inches 1934

On the street which is now known as the FDR Drive, there are several revolving bridges. The artist was especially interested in the play of lines of these structures.

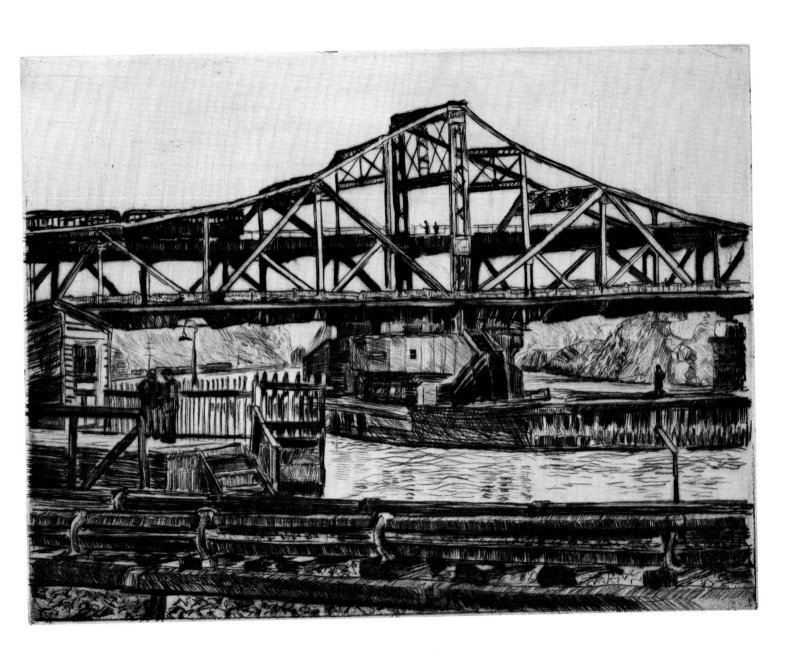

Temple Emanuel with Pine
Drypoint 10 x 7 inches 1931

Temple Emanuel, founded in 1845, is the oldest Reformed synagogue in New York City. Since 1929 it has been located at Fifth Avenue and 65th Street, occupying the site of the former Astor mansion. A huge hall seats 2500 worshippers, a greater capacity than that of Saint Patrick's Cathedral.
 As seen from Central Park opposite the Temple, the pine tree in the foreground serves as a prominent element in the composition, contrasting with the delicate lines of the architecture.

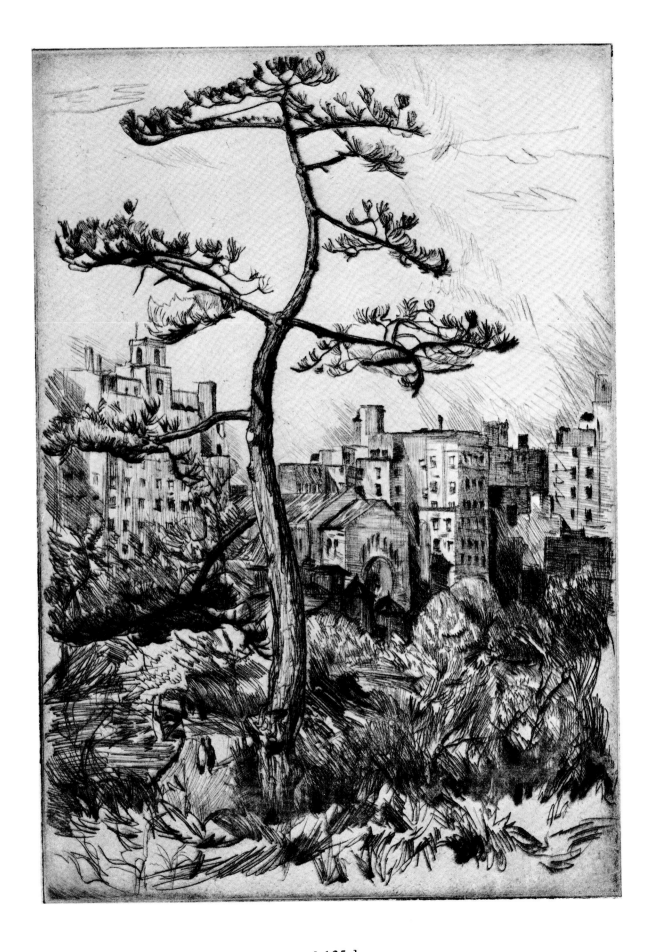

The Zoo and Plaza Towers
Drypoint 10 x 12 inches 1930

In the foreground is depicted the Central Park Zoo, near Fifth Avenue. The view of the tall buildings that surround the Park here portrays one of the special moods of New York City.

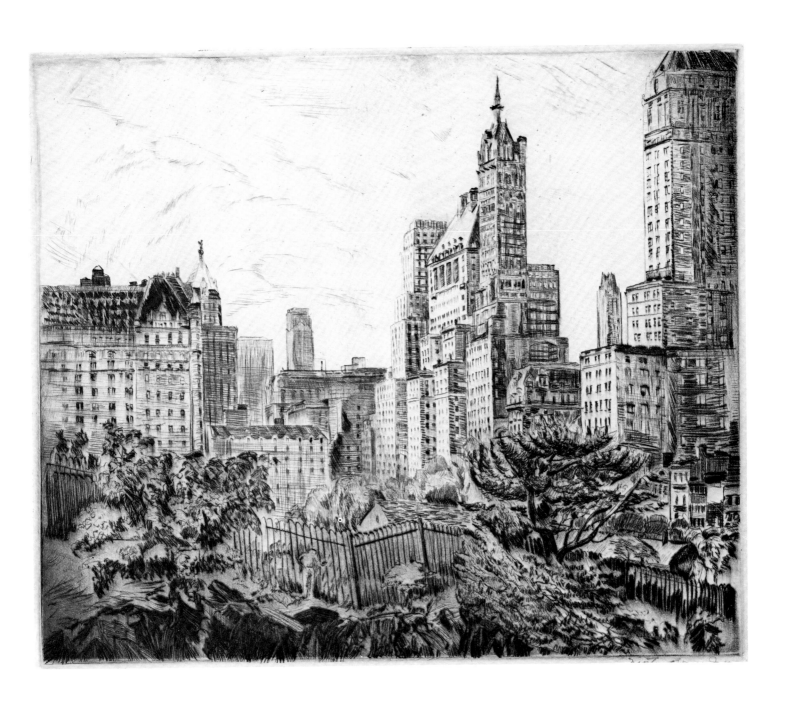

Henry Street, Brooklyn Heights, Winter
Drypoint 10 x 7 inches 1941

*Brooklyn Heights, beautifully situated on a bluff facing the East River, at-
tracted many artists. In a three-story house on State Street, around the cor-
ner from Henry Street, lived three artists: Adolph Gottlieb, Louis Shanker
and Mortimer Borne.*

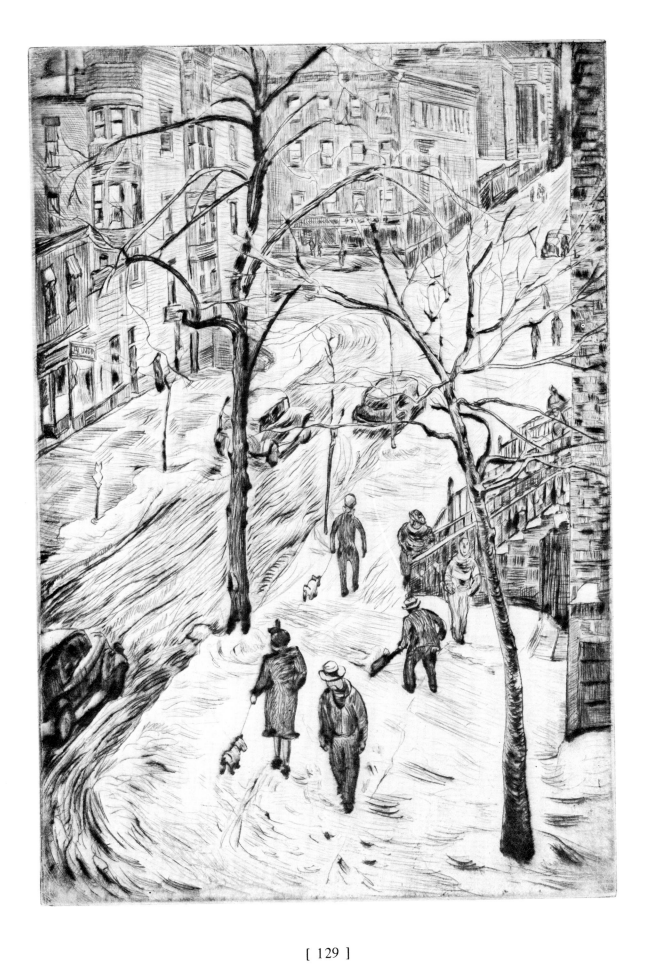

New York from Weehawken
Drypoint 7 x 10 inches 1929

Mortimer Borne took his inspiration from an extraordinary range of subjects, but one of his most enduring fascinations has been New York City. One day, Borne decided to visit Weehawken, New Jersey, which is on the Hudson River northeast of Jersey City. He took the ferry from Cortlandt Street to Weehawken. Passenger fare in 1929 was six cents. As usual, he carried his drypoint materials and created this print directly on the copper plate.

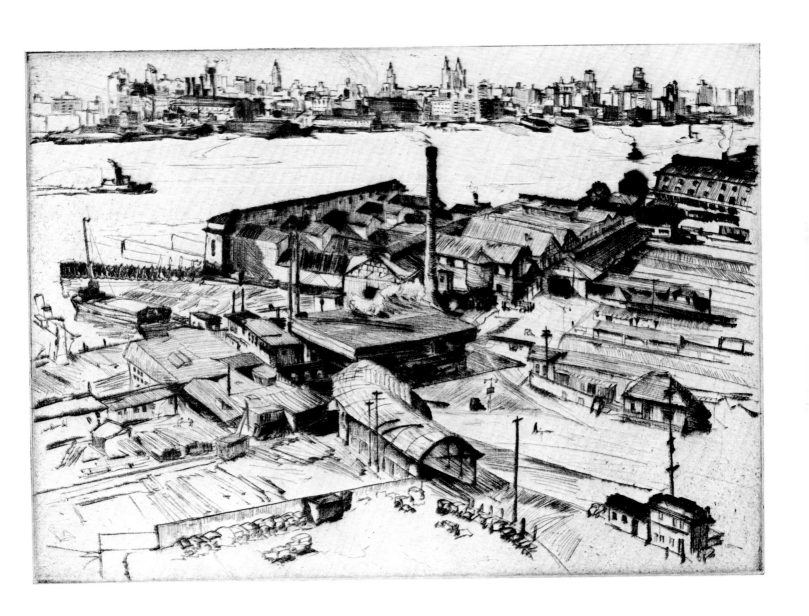

Verdi Square
Drypoint 9 x 12 inches 1939

*Verdi Square is located at the junction of Broadway and Amsterdam Avenue
at West 72nd Street. In the square, on a fifteen-foot granite pedestal, stands
a bronze statue of the composer Giuseppe Verdi. Grouped around the ped-
estal are four life-size figures depicting characters from the composer's op-
eras. The monument, sculpted by Pasquale Civiletti, was erected in 1906 by
the Italian community,*

*The artist looked through the window of a building on the south side of
the square. He recalls that it was a chilly day, so he found a place where he
would be sheltered from the wind while he worked.*

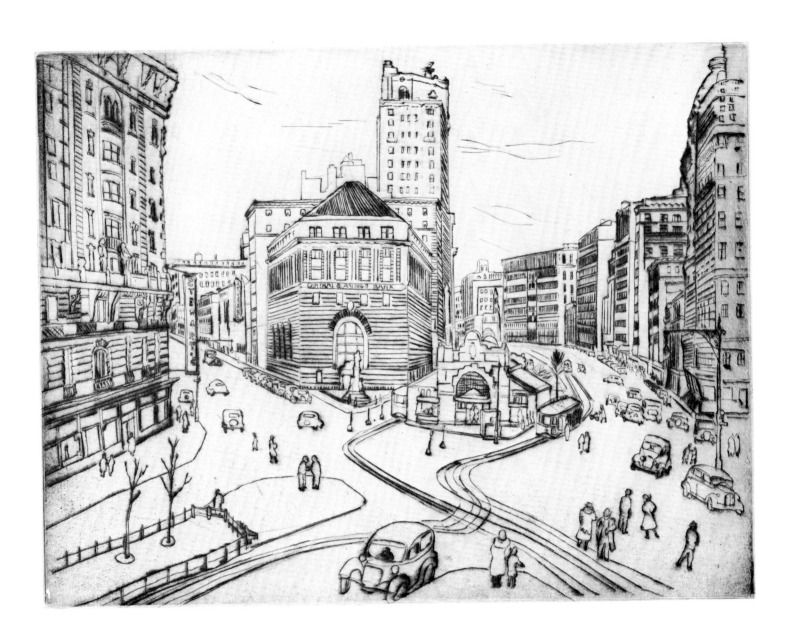

Houseboat on the Hudson
Drypoint 8 x 10 inches 1934

One of the most beautiful rivers in America is the Hudson River, which flows through wooded hills. This print shows, at the foot of Riverside Drive, a houseboat used for leisurely cruising, one not suited to rough waters.

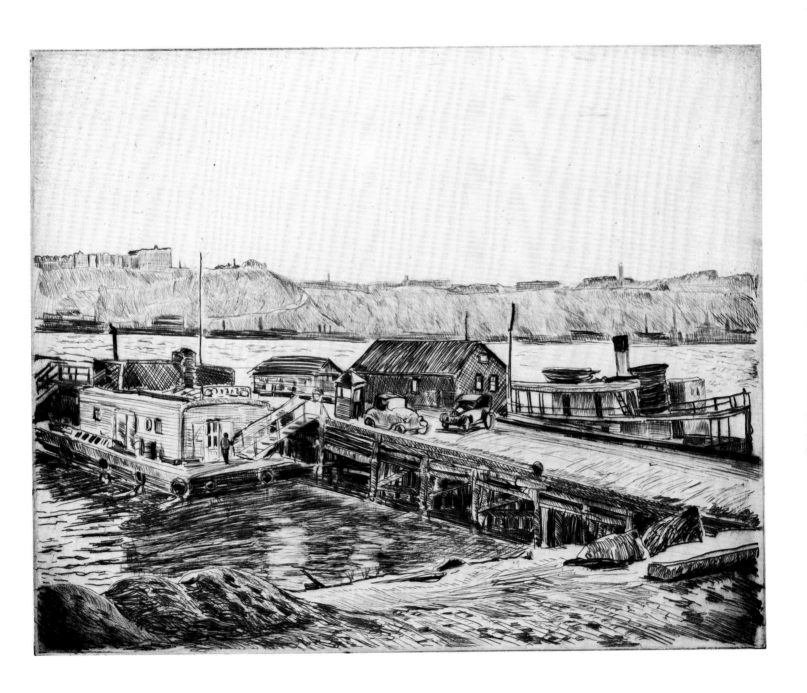

Restless Night (Based on Mid-Manhattan)
Drypoint 6 x 7½ inches 1940

The artist conceived this print on a summer night, a night too hot for sleep-ing. He amused himself by creating this fantasy based on images of Mid-Manhattan.

Even the strictly "down to earth" National Academy could not resist the charm of this drypoint, and it was exhibited there that same year.

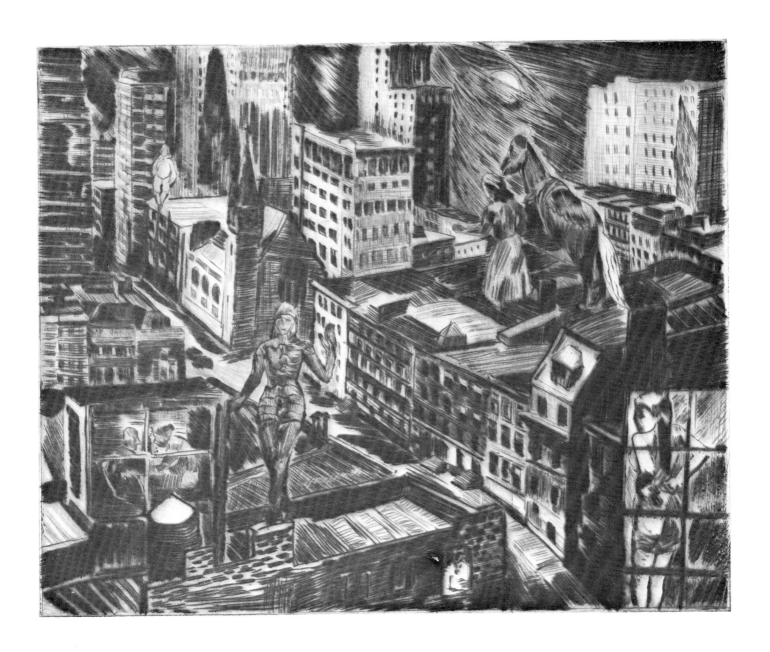

Pushcarts, Lower East Side
Etching 5 x 6½ inches 1927

The two square miles of tenements and crowded streets of the Lower East Side magnify all the problems and conflicts of big-city life. Many tenements standing today are of the kind banned in 1901. Most were built in the 1880s and 1890s, but some antedate the Civil War.

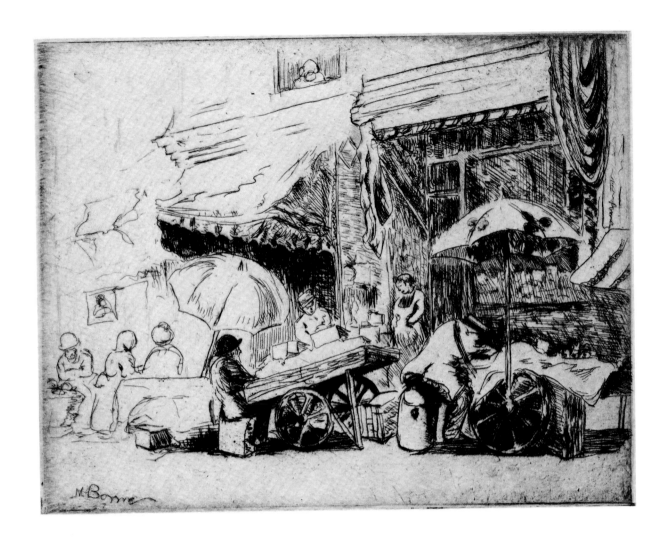

The Farmer and His Wife
Drypoint 7¾ x 10 inches 1941

In the summer of 1941, the artist spent several days in Carlstadt, New Jersey. In those days there were many truck farmers in Carlstadt. The flat cultivated land and shiny stalks of corn combined in a pattern which interested Borne. The farmer and his wife were completely oblivious of the artist as he sat working a short distance away.

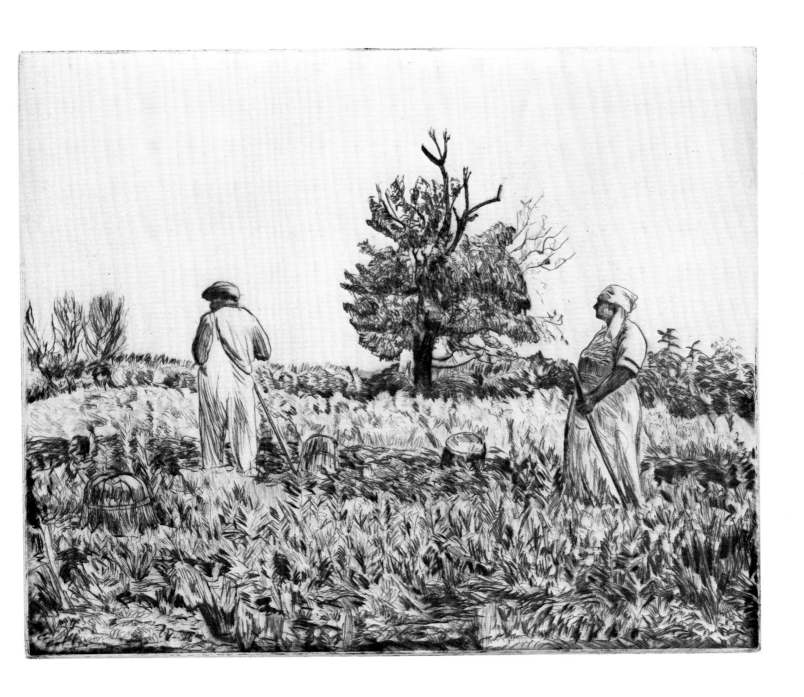

Two Nudes at a Brook
Drypoint 7 x 10 inches 1930

During the summer of 1930, the artist had his studio in East Norwich, Connecticut, in an abandoned farmhouse surrounded by acres of land and a brook. This drypoint depicts two female nudes at the brook.

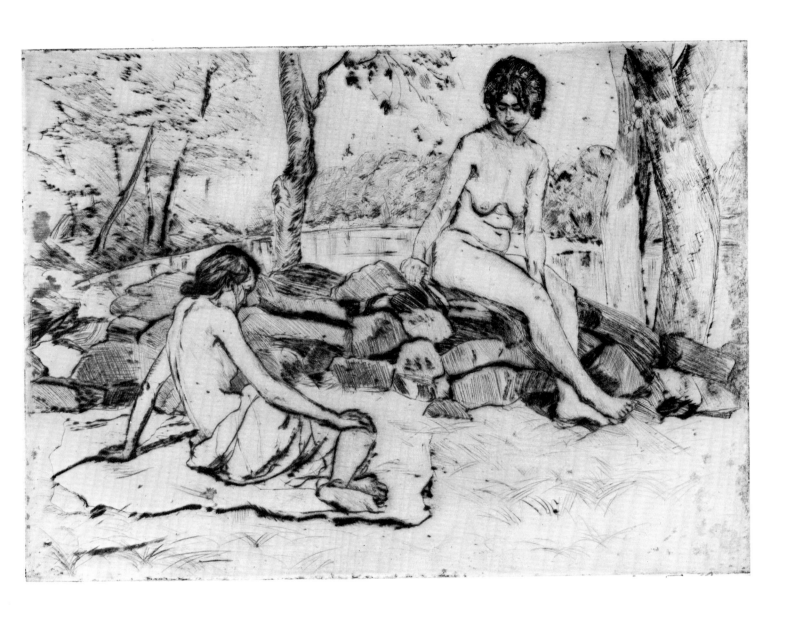

Indian Weaver
Drypoint 10 x 8 inches 1933

*In the 1930s, many Navajo Indians of the Southwest were forced to obtain
income away from their reservation because of overgrazed and eroded grass-
lands. At that time, a man by the name of Wick Miller used to bring a
group of Indians to the Brooklyn Museum every year, to demonstrate and
sell their crafts.*
 *Borne brought his copper plate and drypoint needle to the Brooklyn
Museum and created this print of a Navajo weaver making a rug with a
primitive loom.*

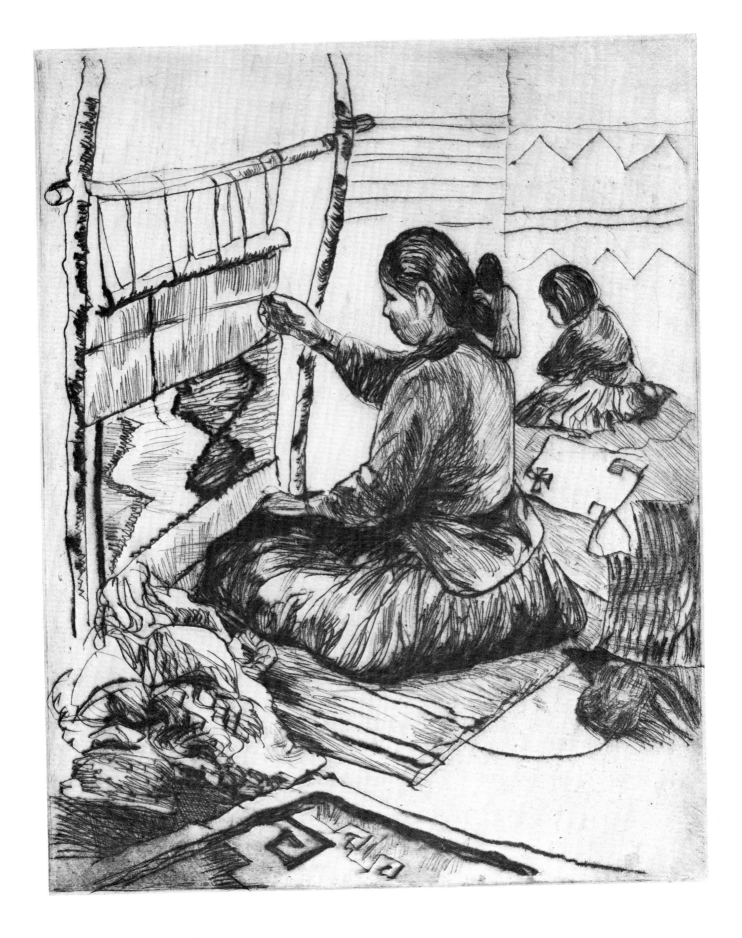

The Porch, Woodstock, New York
Drypoint 8 x 10 inches 1929

Woodstock, nestled in the Catskills, was incorporated in 1787, and remained a sleepy little village until 1902. The Art Students League of New York City established an art school there a few years later and Woodstock blossomed into an art colony. Even today it is a favorite with artists, writers, musicians and actors.
 During the hot summer of 1929 the artist moved his studio to Woodstock, where he could indulge his love of nature and his fascination with humble subjects esthetically treated.

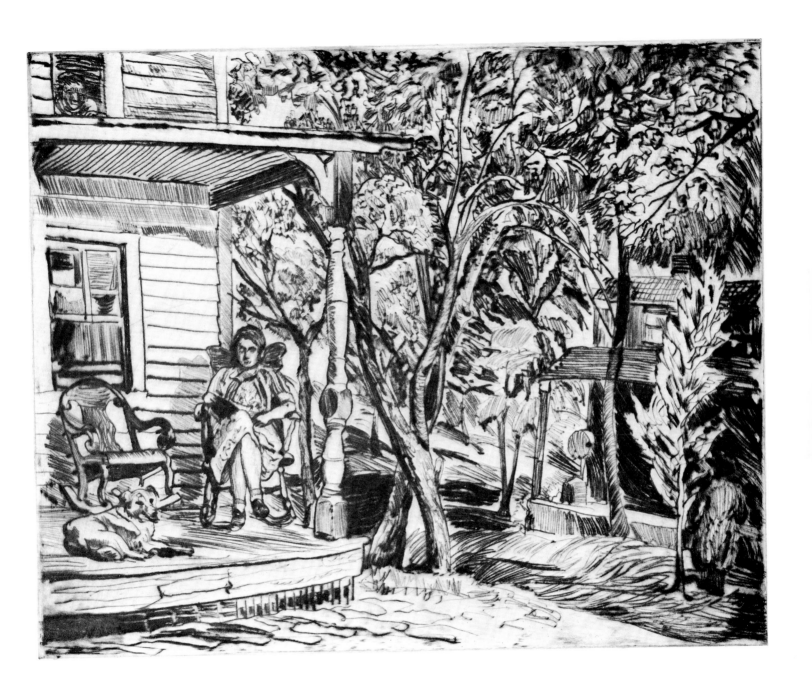

The Cat
Drypoint 10 x 8 inches 1941

One summer, while vacationing in the Connecticut woods, the artist found a cat. He took the animal in and fed it. The cat subsequently became the model for this print.

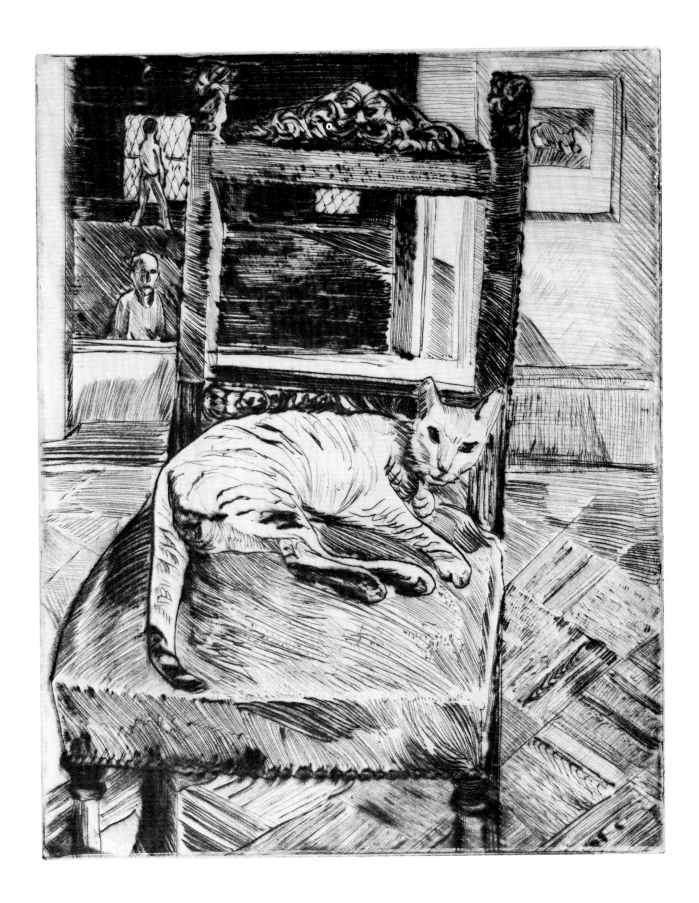

Still Life
Drypoint 8 x 5 inches 1931

Still life as an artistic subject stems from the classical past, and nearly every major artist of the twentieth century has explored its possibilities. With Chardin, this subject matter took on a new importance; Cezanne made still life a prominent part of his oeuvre.
 In 1932, the Art Institute of Chicago circulated this print to other museums in the United States (see Documentation).

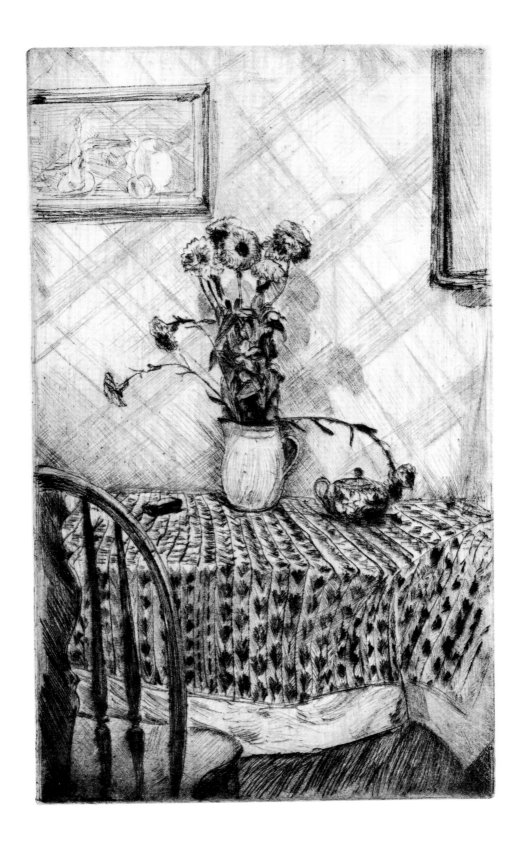

King David Street with Fruit Vendors, Jerusalem
Drypoint 10 x 7 inches 1935

The main thoroughfare in the Old City of Jerusalem, King David Street, is a narrow cobblestone street punctuated by steps at frequent intervals. Here, men, animals and objects mingle with flashes of color, sound and smell. The stolid and patient vendors, immersed in their private time capsules, call out their wares for sale. Time seems frozen...One can almost breathe the air of the time of King David.

Absorbed in his work, the artist lost all sense of now until recalled into reality by an Arab urchin who nudged him, asking for "bakshish," apparently in payment for allowing this stranger the privilege of occupying a spot on the street.

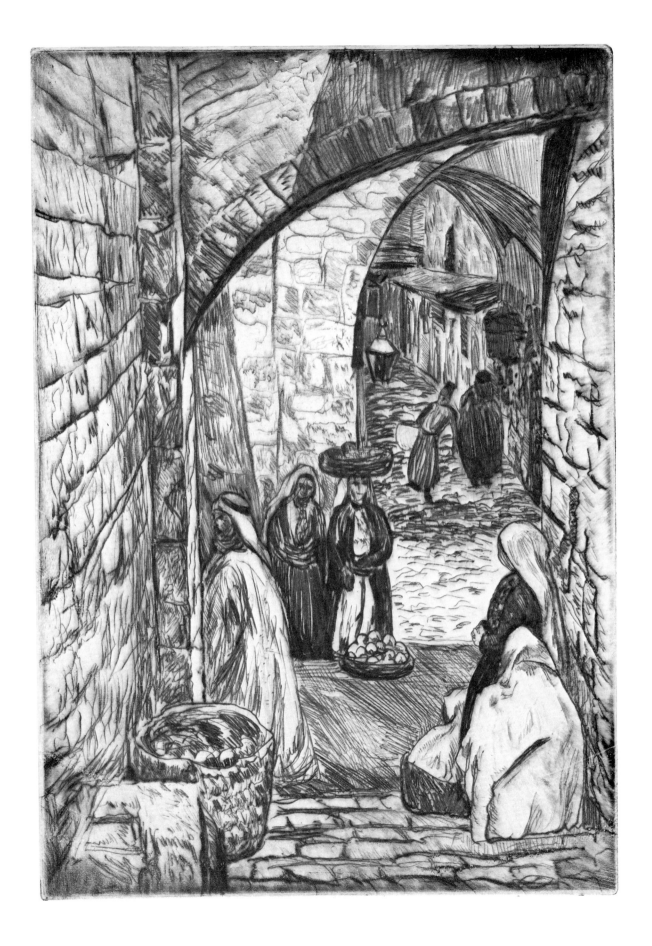

Tower of David, Jerusalem
Drypoint 7 x 10 inches 1935

*Mount Zion in Jerusalem is the site of King David's tomb. The structure,
known as the Tower of David, contains one of the seven gates that leads to
the Old City of Jerusalem. From the Mount one can look down into old
Jerusalem and see the sole remaining wall of the Second Temple, that is,
King Solomon's Temple, rebuilt by King Herod the First. This wall is
known as the Wailing Wall or Western Wall.*

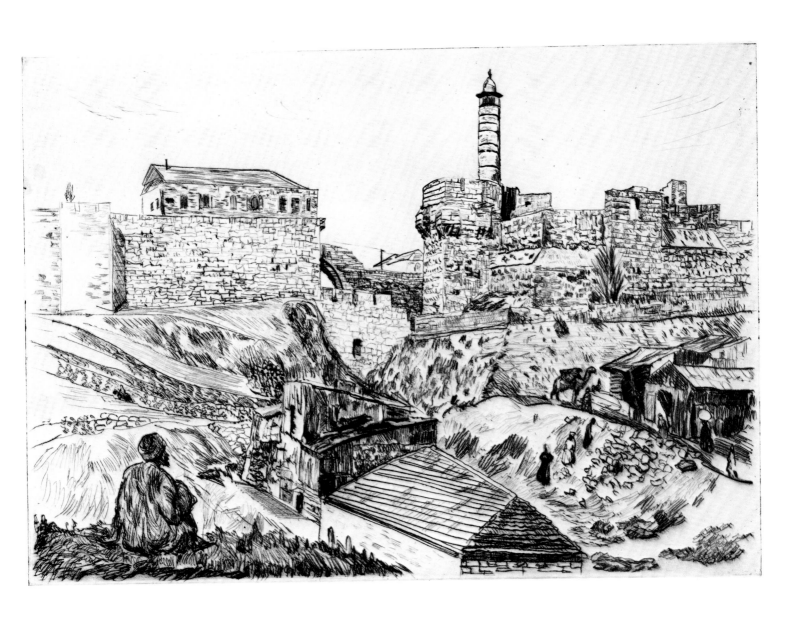

Olive Trees, Jerusalem
Drypoint 7 x 9 inches 1935

In the section of old Jerusalem called Sanhedria, the olive trees show their desperate efforts to survive; the roots occasionally rise above the ground in their search for water. The gnarled trunks, the exposed roots, the silvery greens of the leaves are silent witnesses to the march of time and the struggle of the ancient to survive.

The scene is the Bokharan Quarter of Jerusalem, close to the caves where the members of the Sanhedrin were buried from the fifth century B.C. to 70 A.D.

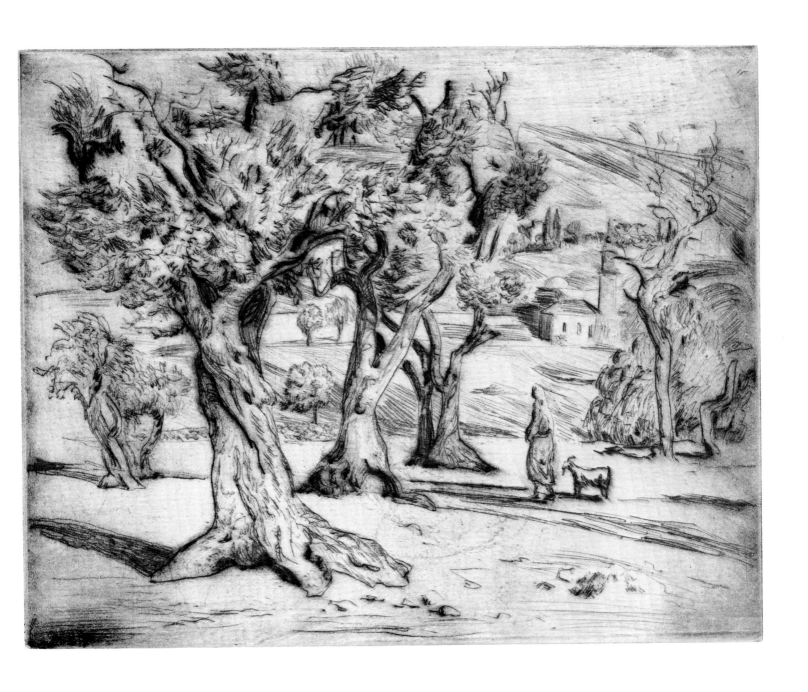

Market Place, Mea Shearim, Jerusalem
Drypoint 6½ x 7½ inches 1935

*Mea Shearim (One Hundred Gates), religious quarter of Jerusalem, dates
from the end of the last century and is inhabited primarily by orthodox Jews
gathered to Jerusalem from the Diaspora.*

*The ceaseless comings and goings of the traders and tourists create the
mood of the district.*

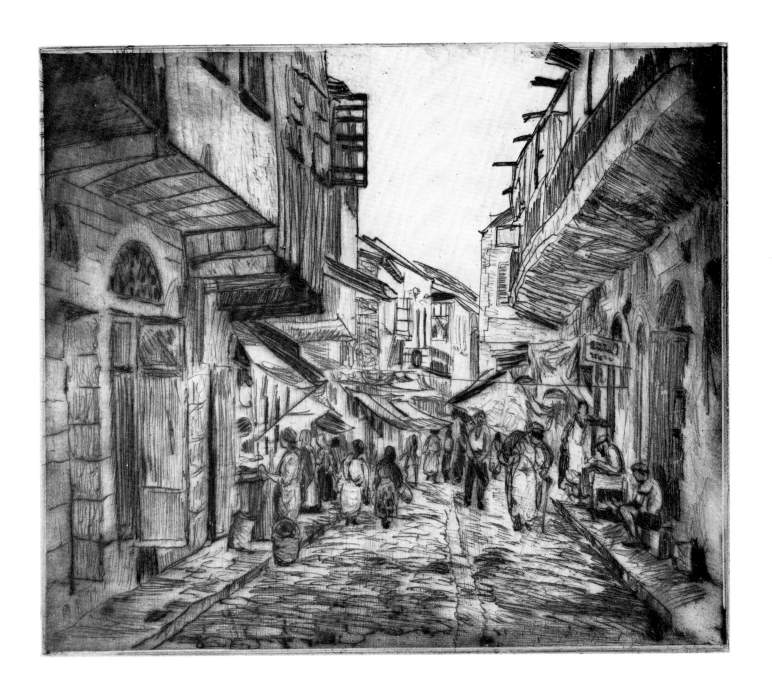

Under the Olives
Drypoint 7 x 10 inches 1935

Following his one-man show of drypoint prints in Jerusalem in 1935, the artist decided to stay on for several months and work there making prints. One of his favorite subjects was the Sanhedria district in old Jerusalem.

Here orthodox Jews and Arabs, and their ubiquitous goats, lived together in harmony.

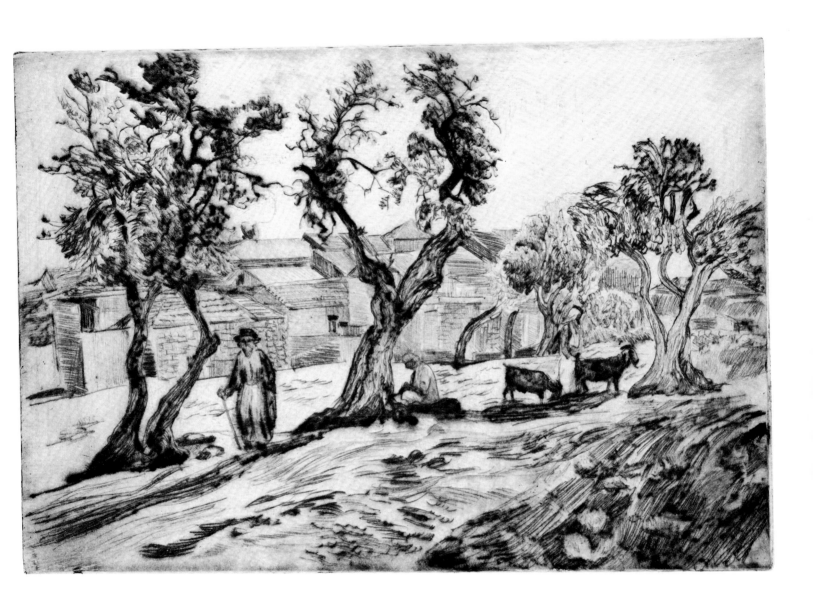

Butcher's Stall, Mea Shearim, Jerusalem
Drypoint 6 x 8 inches 1935

During his stay in Jerusalem, the artist wandered through winding streets paved with stones polished by millions of footsteps over several thousand years. This print depicts one of the oldest market places in Mea Shearim.

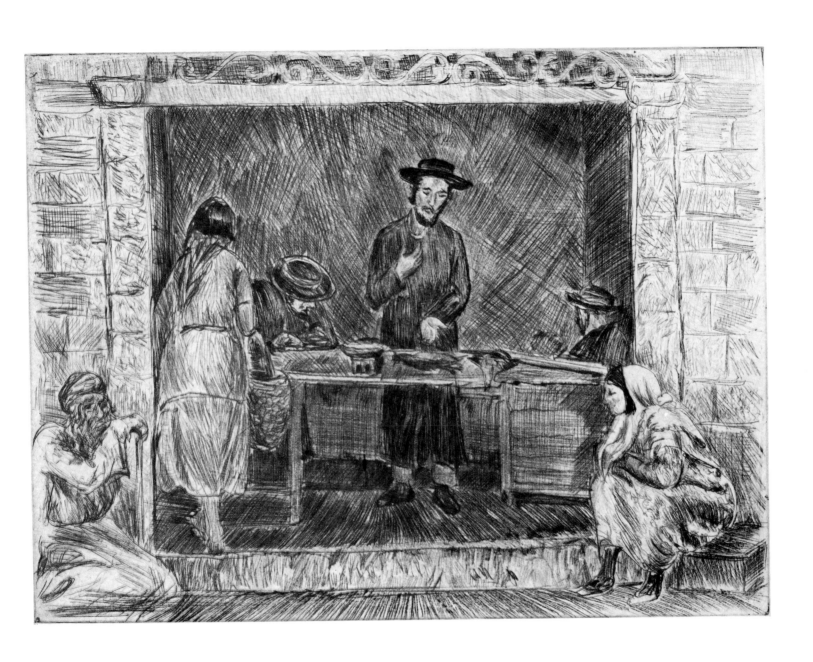

Man from Bokhara
Drypoint 7 x 5 inches 1935

Bokhara in Turkistan was formerly a trade and cultural center of the Islamic world. In the thirteenth century it was conquered by Genghis Khan. Now it is incorporated into Uzbekistan, in the southwestern part of the Soviet Union.

 It was in the Old City of Jerusalem that the artist met this Jewish jeweller from Bokhara. After Borne befriended him, the man from Bokhara willingly posed for this drypoint.

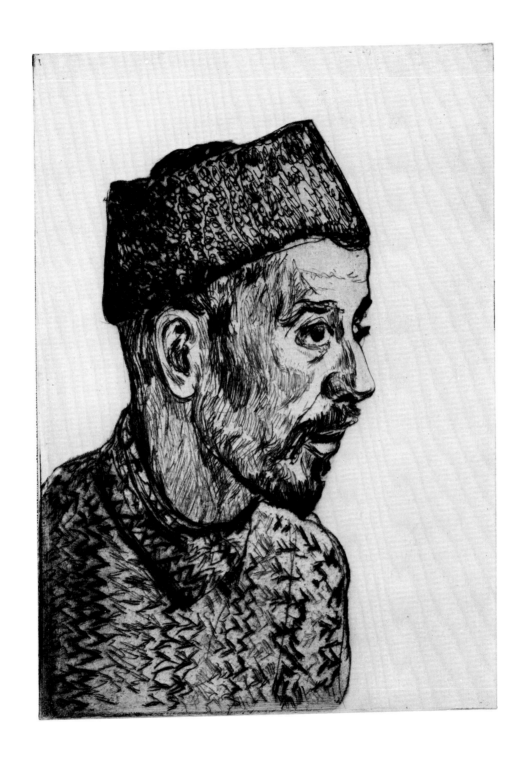

The Drinker
Drypoint 6 x 5 inches 1930

The artist saw in this subject not only the simple gesture of a woman drinking, but also patterns of light and dark, and distributions of linear directions. He chose only those elements which he considered necessary to produce a unity of concept.

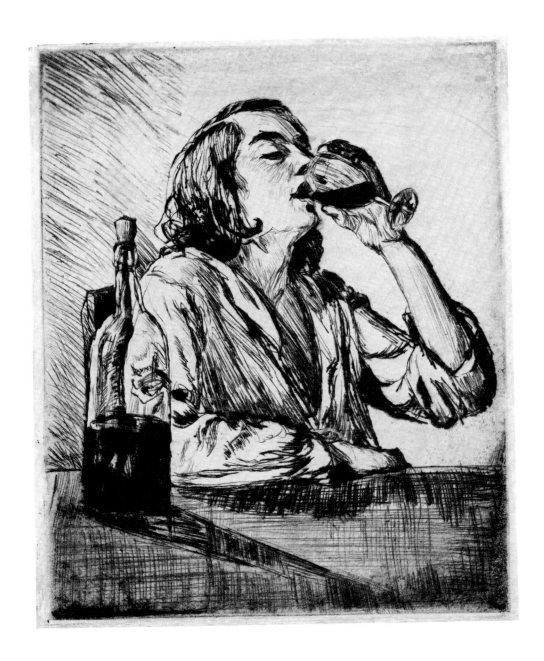

Joseph Pennell
Etching 12 x 9 inches 1926

Jospeh Pennell (1857-1926), American illustrator, etcher, lithographer and author, taught at the Art Students League in New York from 1922 to 1926.
 At times, Joseph Pennell would join his students in the school cafeteria. On one of those occasions, Borne was in the cafeteria with a grounded plate, intending to make a portrait of one of the students. Joseph Pennell posed for him instead.

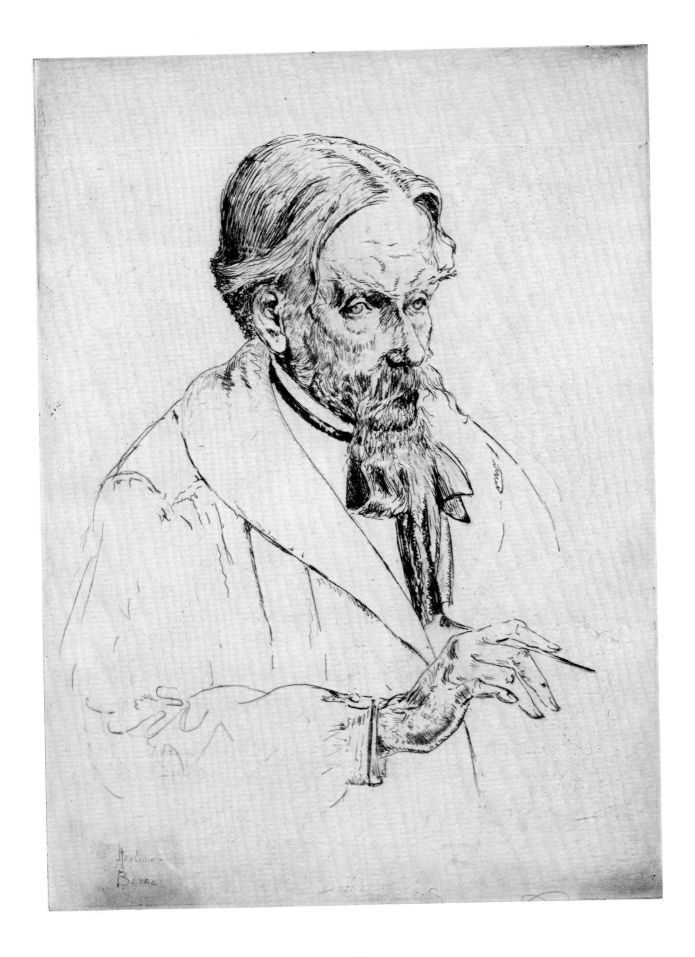

Louis Michel Eilshemius
Drypoint 8¼ x 6½ inches 1933

This is a portrait of Louis Michel Eilshemius (1864-1941), American eccentric painter, son of a wealthy Dutch importer. He received no significant recognition for more than thirty years; he lived in utter poverty in New York City near Borne's 60th Street studio, where this portrait was made.

 Today, Eilshemius's imaginative, atmospheric landscapes are in the collections of some leading museums.

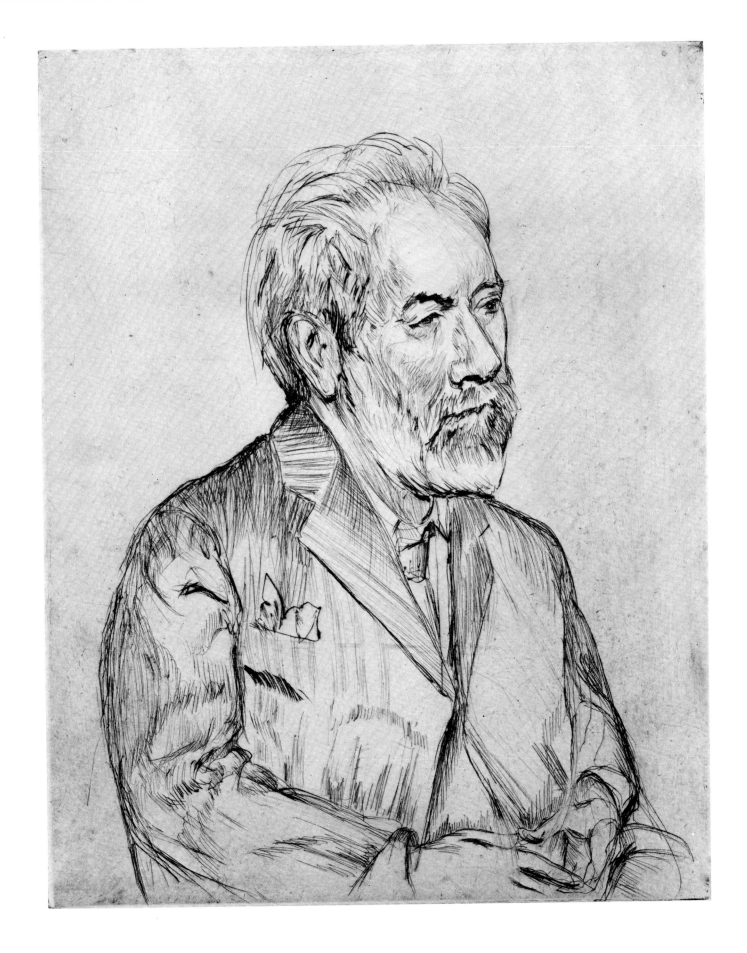

Self-Portrait
Drypoint 7 x 5 inches 1935

On the way home to the United States from his one-man show in Jerusalem, the artist stopped over in Paris for a few days where he made this self-portrait. The artist's intention was to use as few lines as possible in a controlled manner.

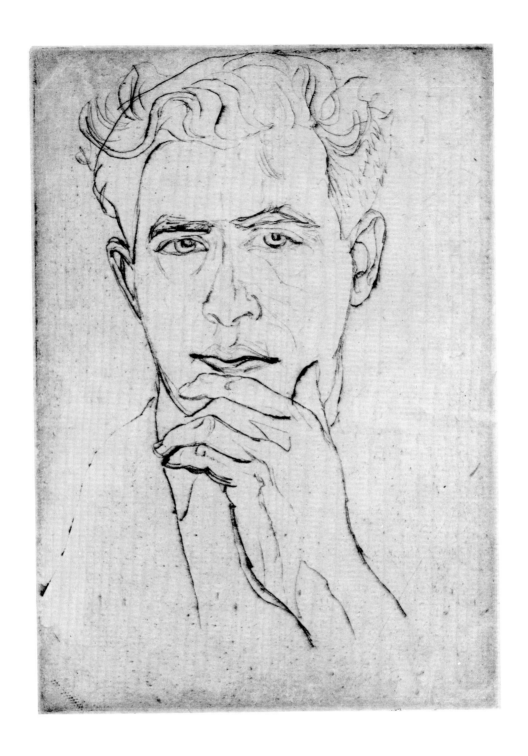

Yemenite Rabbi
Drypoint 5¼ x 6 inches 1935

In 1935, it was a rare event to meet a Yemenite Jew in Jerusalem, especially a Yemenite Rabbi, who would consent to pose for a portrait.
 By 1950, more than 50,000 Jews had emigrated to Israel from the republic of Yemen.

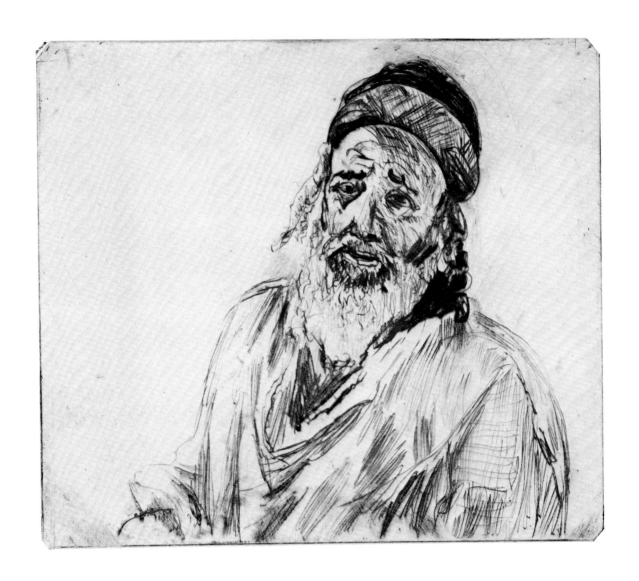

R in Pensive Mood
Drypoint 10 x 8 inches 1943

Here the artist's intention was not to produce a likeness of an individual; he selected only those elements that contributed to the esthetic image.

The diamond-pointed needle used to produce this print cut into the copper deeply, throwing up a solid burr which resulted in the rich, velvety black of the lines, a typical characteristic of the drypoint technique.

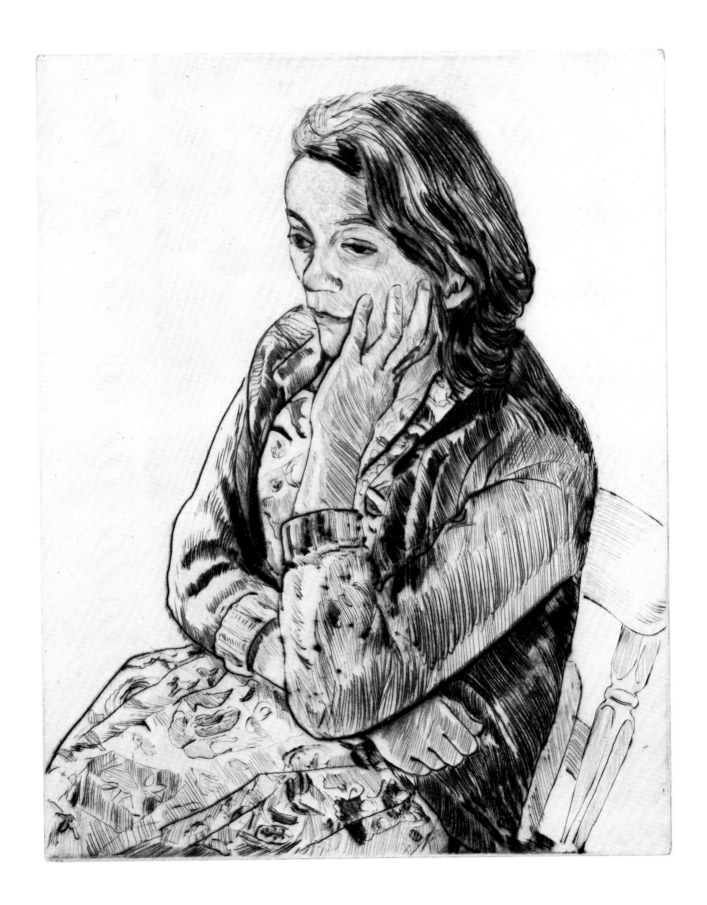

Cornfields and Willows
Drypoint 8 x 10 inches 1933

The image of lush leaves of corn striving upward toward the sun, and drooping branches of willows reaching down toward the ground, embodies the fruitful earth of Rockland County, New York.

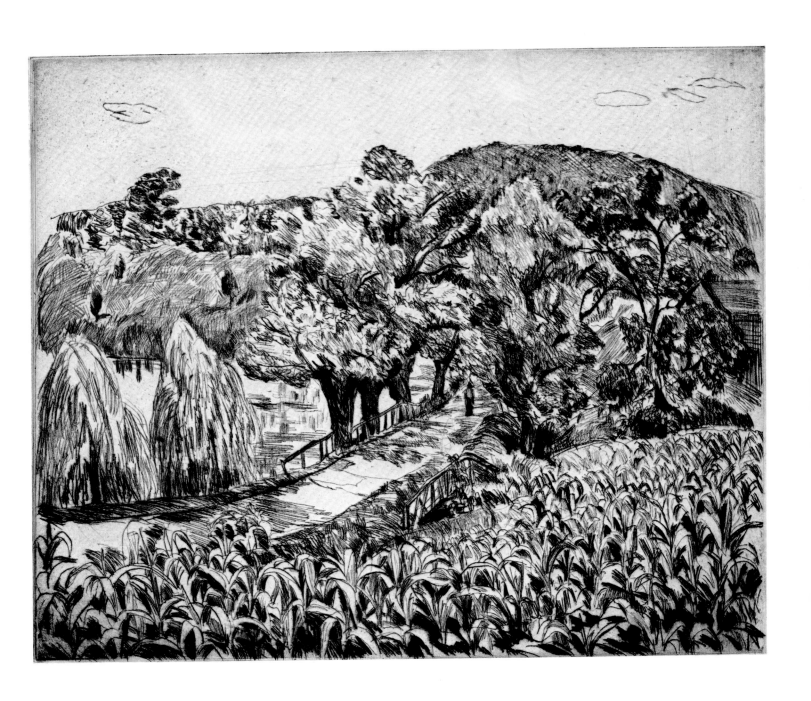

Connecticut Woods
Drypoint 10 x 7 inches 1930

To escape the heat and grime of New York City in the summer of 1930, the artist moved his studio to East Norwich, Connecticut.

This print, among others, was exhibited in Shanghai, China, in a one-man show. The exhibition was reviewed in the North-China Sunday News *(see Documentation). The review emphasized Borne's wide range of subjects, as well as the versatility of his skill. This print, as well as* The Drinker *and* Plaza Towers, *were illustrated in the review.*

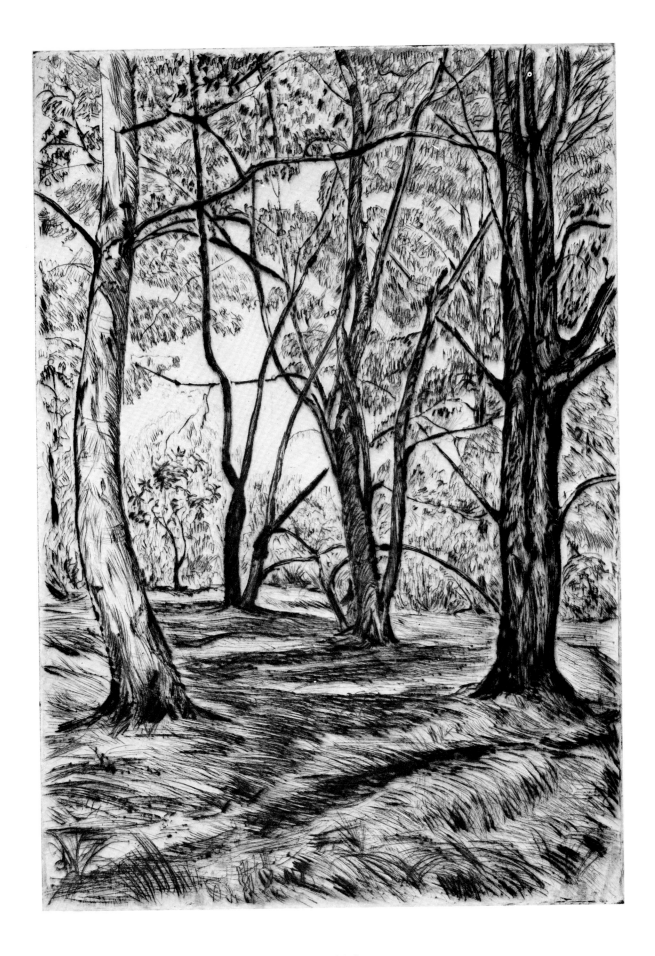

Apple Trees
Drypoint 6 x 8 inches 1933

Rhythmic configurations in nature are especially noticeable in trees. The directions assumed by the branches correspond to human gestures in the artist's vision, and evoke esthetic ideas. The artist selected those "gestures" with which he could identify.

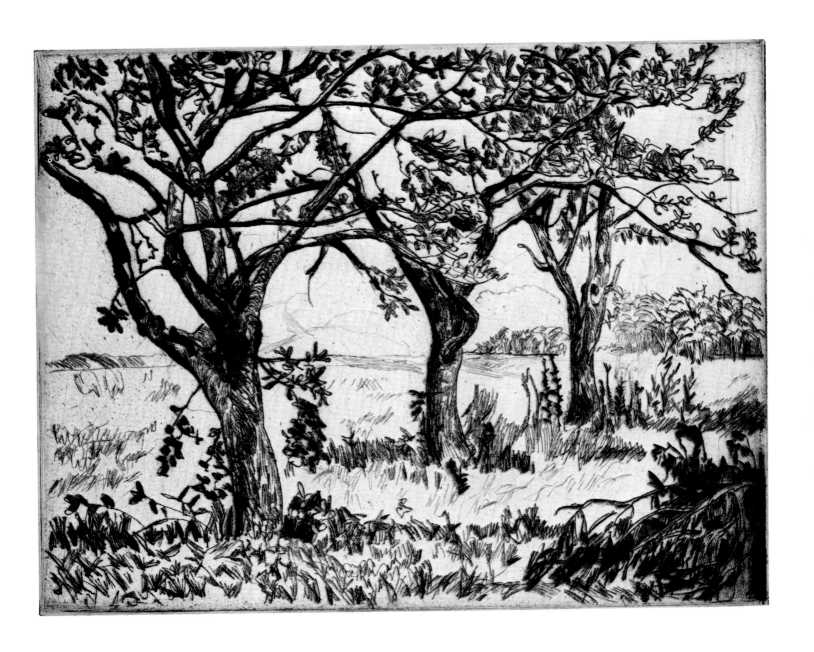

Woodstock, New York
Drypoint 8 x 10 inches 1929

During the artist's stay in Woodstock in the hot summer of 1929, he noted this old house surrounded by lush greenery and an abundance of trees. This was typical of the houses occupied by artists in the summertime.

The house seemed to be hiding from the pragmatic activity of the outside world. The romantic setting suited the moods of the New York esthetes searching for respite from the hard stones and macadam streets of the city.

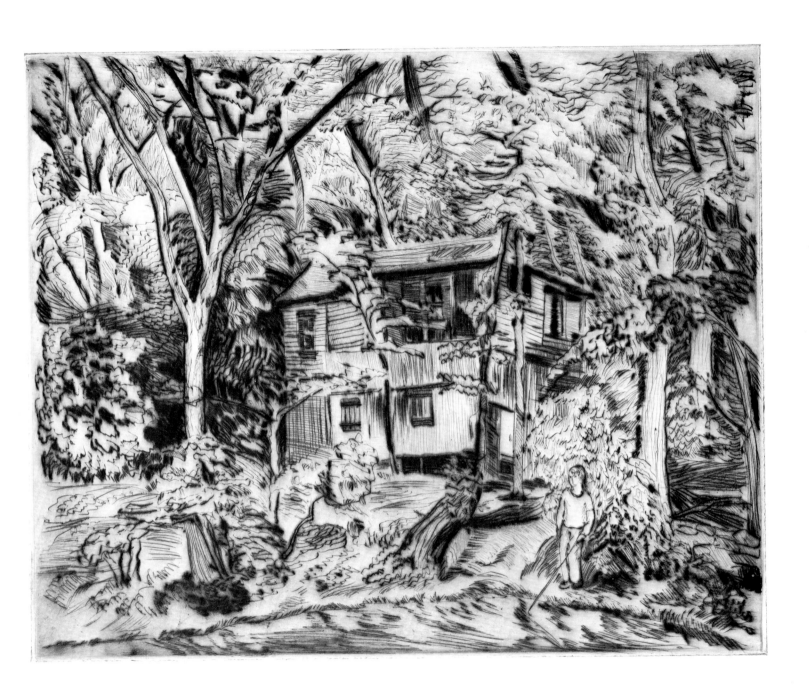

Mortimer Borne's career as a professional artist began in the 1920s. Some of his etchings and drypoints, dated as early as 1926, are in the permanent collections of a number of museums, including the Metropolitan Museum of Art, which now owns more than one hundred examples of his prints, dated 1926-1973.

In 1930, Frederick Keppel & Co., New York, in existence for more than half a century and featuring prints by Rembrandt, Dürer, Whistler and other masters, recognized the quality of Borne's work and became his official gallery.

1932 **The Art Institute of Chicago,** The First International Exhibition of Etching and Engraving, May. At the close of the exhibition, Borne's drypoint, "Still Life," was selected for a yearlong tour of other American art museums.

Shanghai, China. Borne's one-man show of etchings and drypoints reviewed in *The North-China Sunday News,* September 18, page 5:

> A Leading Etcher's Work...Mortimer Borne, a young American artist, has gained a noted reputation within the last few years. He shows an unusually versatile skill in his choice of subjects, of which the above is an example ["Connecticut Woods" illustrated]. New York buildings are his most favored subjects ["Plaza Towers" illustrated]. Another study by Mortimer Borne showing his wide range of subjects ["The Drinker" illustrated]...His work has been entered in several noted exhibitions in America.

1935 **Gallery Hachadasha, Jerusalem** (The New Gallery). One-man show of etchings and drypoints; reviews in Hebrew.

1938 Borne conceived "A Plan for the Interchange of Artists between the Americas to Promote Good Will and Mutual Understanding between Our Peoples." His motto was, "Than the artist there is no better ambassador of good will."

1939 Borne's plan resulted in the Conference on Inter-American Relations in the Field of Art, Department of State, Washington, D.C., Oct. 11-12.

Preliminary Survey of Inter-American Cultural Activities in the United States, U.S. Department of State, September 25, 1939, page 125: "The program includes the interchange of works of art...and the realization of a federally sponsored interchange of artists."

Analysis and Digest of the Conference Proceedings, U.S. Department of State, January, 1940, page 24:

> Mortimer Borne of the United American Artists, as Chairman of the Committee for the Interchange of Artists between the Americas, proposed a plan whereby a large number of artists representing all schools of artistic thought would be sent to record their unbiased impressions and feelings about Latin American life; likewise, that an equal number of Latin American artists come here for the same purpose. Because the individual artist represents group tastes, this will be tantamount to the interchange of vast numbers of people, he declared.

PM, July 23, 1940 (editorial page): "Many readers asked about...a Pan-American Exchange Plan which artist Mortimer Borne has worked on almost single-handed..."

American Society of Etchers Annual Exhibition. Borne won the Talcott Prize for best print ("Rainy Night").

Delphic Studios, New York, April 10-23. One-man show, catalog comments by Marchal E. Landgren:

> Mortimer Borne works directly on the copper plate without preliminary sketches...This respect for the advantages, as well as the limitations of a medium, is a rare quality in contemporary art production...His subjects are not lost in stylization or show of technique.

New York Post, April 15, comments by Jerome Klein:

> At the Delphic Studios are drypoints by Mortimer Borne. These prints of life in the Near East, as well as Manhattan and Weehawken are done with technical fluency and a variety of graphic qualities from pure line to rich tonal handling.

Art Digest, April 15:

> Borne's taboos, to quote him, are: "The stylized synthetic line and the etching that imitates other mediums — because I believe that the line needs no other adornment. I prefer a homely subject sensitively expressed to an imposing subject superficially done."

New York Herald Tribune, April 16, comments by Carlyle Burrows:

> Mortimer Borne has exhibited his work in leading national art shows...His subjects are moody in feeling and vigorously handled...One of Mr. Borne's most comprehensive undertakings is a series of scenes executed in the Near East.

New York World's Fair, Exhibition of Contemporary American Art. Borne's drypoint, "Rainy Night," exhibited and reproduced in art magazines and books.

1941 **The Corcoran Gallery of Art,** Washington, June 7-29. One-man show, catalog comments by John Taylor Arms:

> "Mr. Borne has made a notable contribution to Contemporary American Graphic Arts, and his prints worthily express the depths and sincerity of his feelings and the skill of his execution ...He is able to interpret his conceptions with clarity, without hesitation, and with a feeling as discerning and sensitive as it is forthright.

Art Digest, July 1. Leila Mechlin of *The Washington Star* commented approvingly on Borne's views of New York, including "Lower Manhattan" (illustrated).

1942 **Museum of Fine Arts,** Montreal, March 20-April 10. One-man show. *Montreal Daily Star,* March 24: "Mortimer Borne, an American etcher, has an exhibition of some thirty of his drypoints...These are strong prints, with fine drawing and nice gradations of tone."

1943 **Library of Congress,** First National Exhibition of Prints. Borne's drypoint, "Henry Street, Winter," included in this show. His prints were also shown in subsequent annual exhibitions.

Society of American Etchers 28th Annual Exhibition. Borne's drypoint, "Landscape, Site of World's Fair," won the Noyes Prize for best print, and was reproduced in *Art Digest,* December 1.

Grand Central Art Galleries, New York, December 7-18: One-man show of "Drypoint Prints from Color Plates."

1944 **New York Public Library,** May. Exhibition including Borne's color drypoints reviewed by H.M. in the *Bulletin* of the New York Public Library:

> News of the Month: Mortimer Borne and a Note on Color Prints...The Library's recent acquisition of drypoints in color by the American etcher Mortimer Borne, which are now on exhibition in the print room together with examples of color printing by Joannes Teyler, Charles Henri Guerard, Jean Francisque Raffaeli and Mary Cassatt, has prompted a brief survey of color printing by line engraving, etching, and drypoint... Mortimer Borne is the first to utilize the drypoint process for color printing from three plates.

Progressive proofs of the color drypoint "The Road," that is, red, yellow, blue and finished proofs, were included in the exhibition and are in the permanent collection of the New York Public Library.

Washington Post, November 17, comments by Jane Watson: "Mortimer Borne's experiments with drypoint as a medium for color prints have already been recognized as a valuable contribution to the art of printmaking."

Smithsonian Institution, United States National Museum, Division of Graphic Arts, Washington, November 20-December 17, "Color Drypoints, a New Medium by Mortimer Borne." Catalog comments by Mortimer Borne:

> Joannes Teyler (1648-1700) applied inks of different colors to *one plate*. Subsequently artists used aquatint, mezzotint, or wood blocks to obtain color areas and these were combined with an etched, engraved or drypoint outline...For many years my aim was to develop an intaglio color medium that would retain a unified drypoint character without sacrificing subtlety of color-tone variations and rhythm of line. This I found could be accomplished by the use of three drypoint plates without any supplementary tone media.

The Sunday Star, Washington, December 10, comments by Leila Mechlin:

> Exhibition of Mortimer Borne's Dry Points in Color at National Museum...Drypoints in color by Mortimer Borne are unique and very interesting, especially to printmakers and collectors...By way of demonstration Mr. Borne has included in his exhibition a print in process — one plate printed in yellow ink, one in blue and one in red, with the finished product [color drypoint, "The Road"].

1945 **New School**, 66 West 12th Street, New York. From 1945-1967, Borne gave a series of art lectures. Some of the titles of his courses: "Art as a Form of Thinking," "The Graphic Arts," "Contemporary Art," "Sources and Components of Modern Art," "Dynamics of Line, Form and Color."

Sweet Briar College, Virginia. One-man show reviewed in *The Sweet Briar News*, March 8:

> Foremost Etcher, Mortimer Borne, Exhibits Dry Points...Mr. Borne will demonstrate his methods in dry point and etching...Much of Mr. Borne's characteristic force and freshness is derived from the fact that he works directly on the copper without any preliminary sketches.

The Currier Gallery of Art, Manchester, New Hampshire. One-man show reviewed in *The Manchester Leader*, April 7:

> The dry points in color by Mortimer Borne which will be on view at the Currier Gallery throughout the month of April are of special interest...Mr. Borne has succeeded in developing an intaglio color medium which retains a unified intaglio character without sacrificing subtlety of color-tone variations and rhythm of line...To illustrate the process, Mr. Borne includes in the exhibition a print of "Flowers" showing the steps through which the print passed before the final result was obtained.

Arthur H. Harlow & Co., New York. One-man show. Catalog, *New Color Drypoints*, comments by Howard Devree, art critic of *The New York Times:*

> Mortimer Borne's innovations in color drypoint are very courageous experiments. He is a meticulous craftsman and his sincerity, conviction and the worth of his work are everywhere evident in his prints.

1947 **Department of State**, U.S. Office of International and Cultural Affairs, International Broadcasting Division, New York. In the "University of the Air" program, January 20, Borne's talk, "Art as a Form of Thinking" was broadcast in many countries.

Museum of Modern Art, New York, letter dated March 27, from Alfred Barr, Director, to Borne: "I think I have never seen precisely this technique of color drypoint before..."

Carnegie Institute, Pittsburg. The color drypoint, "Fantasy," was shown at the annual exhibition. Borne also participated in subsequent annual shows.

1954 **The Royal Society of Painters-Etchers and Engravers**, London, 72nd Annual Exhibition, February 20-March 23. A number of American prints were shown, including Borne's.

1955 **Museum of Modern Art**, New York, acquired Borne's color drypoint, "Parade," for the permanent collection.

1959 **United States Embassy in New Delhi**. The color drypoint, "Mahopac Landscape," was selected from Mr. Lessing J. Rosenwald's Alverthorpe Gallery to decorate the embassy.

1960 to 1971 Borne concentrated on perfecting his original techniques of color drypoint, chromatic wood sculpture, convex painting, constructive wood cut and a new method of drawing. He participated in group shows, but would not take time out to arrange one-man shows, except for one in 1965.

1965 **ZOA House**, Tel Aviv, March-April. One-man show of drypoints and chromatic wood sculpture. Guest artist at the Israel Rotary Convention.

Contemporary Arts Institute, London. Letter dated November 18 from the Institute to Borne, after viewing twenty-nine color drypoints: "The quality of your work is superb."

1967 **National Gallery of Art**, Washington. Letter to Mrs. Borne, dated October 9: "We are happy to have your husband represented in our collection with examples of the color drypoint process which he invented."

1968 **Cyril Clemens**, kinsman of Mark Twain and editor of *Mark Twain Journal*, Kirkwood, Missouri. Letter dated March 18: "In recognition of your outstanding contribution to

American art, you have been unanimously elected 'Knight of Mark Twain'."

1969 **New York University Art Collection.** Letter dated June 25 from Ruth Bowman, Curator: "When I teach my print connoisseurship course in the spring of 1970, be assured I shall be making use of the material on your innovative techniques and shall include it in my class bibliography."

National Gallery of Art, Washington. J. Carter Brown, Director, in a letter dated November 19 to Mrs. Borne: "I find your husband's work fascinating and of great versatility."

1972 **Museum of Contemporary Art,** Ibiza, Spain. Borne's color drypoints, "Fantasy," "The Road," and "Biological Abstraction [Microcosm]" were included in an international exhibition entitled "Ibizagraphic-72."

1974 **Nyack College**, Nyack, New York. One-man show, October 27-November 9, of Borne's techniques of color drypoint, chromatic wood sculpture, convex painting, and constructive wood cut. The exhibition was arranged by Marion Howe, Chairman, Artist Lecture Series Committee.

1976 **Museum of Fine Arts,** Houston, September. Exhibition of recent acquisitions: "Among the works featured in the exhibition...are two prints by Mortimer Borne, inventor of the color drypoint technique."

1980 **British Museum,** London. Catalog, "American Prints 1879-1979," January 31-May 4. Borne's drypoints, "Broadway from Trans-Lux Building," "New York from Weehawken," "Negro Preacher," and "Rainy Night," from the museum's permanent collection, are included along with prints by James McNeill Whistler, Joseph Pennell, Mary Cassatt and other American printmakers.

New-York Historical Society, Museum of American History and Art, September-November. One-man show of etchings and drypoints of New York from the permanent collection (more than eighty subjects) scheduled for exhibition.

Bibliography

1939 American Art Today, New York World's Fair. *National Art Society*, p. 252.

1944 H.M. News of the Month: Mortimer Borne and a Note on Color Prints. *Bulletin, New York Public Library*, vol. 48, p. 485.

1947 Mortimer Borne. *Art as a Form of Thinking.* U.S. Department of State, Office of International Information and Cultural Affairs, January 20.

1949 American Prize Prints of the Twentieth Century. *American Artists Group*, p. 25.

1952 Mortimer Borne. Idiomatic Specialization. *Are You Fed Up with Modern Art?* Clarence Canning Allen, ed. Tulsa, The Rainbow Press, pp. 13-15.

1960 Mortimer Borne. Modern Art Goes Below the Surface. *The Rotarian*, October, pp. 15, 57-59.

1964 Woods from 100 Nations Used in Rotary Sculpture by Mortimer Borne. *New York Times*, June 7.

1965 "The Rotary Family of Peoples," Sculpture by Mortimer Borne. *The Rotarian*, April, p. 55.

1966 Mortimer Borne. Art in Science. *Science*, vol. 153, p. 1470.

1966 Review of an exhibition in the United States. *La Revue Moderne*, August, pp. 26-27. ["Parade," color drypoint, illustrated; also sculpture and painting by Borne.]

1969 Mortimer Borne. New Art Techniques, Color Drypoint, Woodcut and Chromatic Wood Sculpture. *Leonardo*, vol. 2, pp. 107-116.

1970 The Chromatic Wood Sculpture of Mortimer Borne. *Natural History*, vol. 79(9), pp. 28-33, 74-78.

1970 *American Prints in the Library of Congress, a Catalog of the Collection.* Karen F. Beall, ed. Baltimore, The Johns Hopkins Press, p. 77.

1970 Ruth Bowman. Leonardo in the Classroom. *Leonardo*, vol. 3(1), p. 133.

1971 Mortimer Borne. Chromatic Versus Polychrome Sculpture. *Leonardo*, vol. 4(3), pp. 257-258.

1974 Mortimer Borne. Idolatry Versus Art. *Sh'ma*, May 31, pp. 117-118.

1974 Mortimer Borne. A Convex Canvas as an Aid to Augment Three-dimensional Illusions in Painting. *Leonardo*, vol. 7, pp. 143-144.

1974 Mortimer Borne. Human Vision in Art and What the Camera Does Not See and Cannot Record. *Transactions, New York Academy of Sciences*, vol. 36(5), p. 490.

1975 In the Service of Art [Portrait of Mortimer Borne]. *The Rotarian*, vol. 127(2), p. 46.

1976 Mortimer Borne. *The Visual Bible: Ninety-two Drawings.* New York, Abaris Books.

1977 R.S. Biran. Review of The Visual Bible. *Leonardo*, vol. 10(4), p. 346.

1978 Mortimer Borne. *Meet Moses, Fifty-four Drawings.* New York, Abaris Books.

1980 Frances Carey and Antony Griffiths. *American Prints 1879-1979* (Catalogue of the exhibition at the Department of Prints and Drawings, British Museum). London, British Museum Publications, Limited.

List of Plates

Color Drypoints

Trinity Church, Wall Street	9
Mahopac Landscape	11
Stone Street, Sunday	13
Church of the Holy Trinity, Brooklyn Heights	15
The Road	17
Fantasy	19
Biological Abstraction [Microcosm]	21
Fundamentals	23
Moses and Aaron Before Pharaoh	25
Parade	27
The Couple	29
Conversation	31
Burliuk in His Studio	33
Odalisque	35
The Stoop	37
The Violins	39

Black and White
Drypoints and Etchings

Rainy Night, New York	43
City Hall with Civic Virtue	45
Plaza Towers, New York	47
Demolition of Sixth Avenue "L" at 14th Street	49
Church at 79th Street and Broadway	51
Stock Exchange from Subway Station	53
Manhattan from Brooklyn	55
Columbus Circle (small)	57
Union Square (large)	59
Broadway from Trans-Lux Building	61
Coal Barges at Dusk, Sheepshead Bay	63
Columbus Circle with Sunkist Billboard	65
East Fulton Street "L"	67
Lower Manhattan Skyline	69
A Thousand Windows, West 42nd Street	71
Construction of West Side Highway	73
Gossips on State Street, Brooklyn Heights	75
Little Bridge, Central Park	77
Times Square	79
Landscape, Site of World's Fair	81
Central Synagogue	83
Dyckman House	85
May Day, Union Square	87
Skaters, Central Park (large)	89
View of Central Park, Winter	91
Skaters, Central Park, Looking West	93
Riverside Drive, Winter	95

List of Plates, continued

Bronx Street	97
Columbus Circle, Erection of Skyscraper	99
Tugboats, Wall Street	101
Indian Hall, Museum of Natural History, New York	103
Union Square, Panoramic View	105
Chinatown, Doyers Street, New York	107
"L" Lines from Roof on East Broadway	109
Negro Preacher	111
WPA Lineup at Times Square [Manhattan Episode]	113
Café	115
79th Street Between Broadway and Columbus	117
Fulton Street "L" with Beecher Monument	119
West Street at 10th Street	121
Revolving Bridge, East River	123
Temple Emanuel with Pine	125
The Zoo and Plaza Towers	127
Henry Street, Brooklyn Heights, Winter	129
New York from Weehawken	131
Verdi Square	133
Houseboat on the Hudson	135
Restless Night (Based on Mid-Manhattan)	137
Pushcarts, Lower East Side	139
The Farmer and His Wife	141
Two Nudes at a Brook	143
Indian Weaver	145
The Porch, Woodstock, New York	147
The Cat	149
Still Life	151
King David Street with Fruit Vendors, Jerusalem	153
Tower of David, Jerusalem	155
Olive Trees, Jerusalem	157
Market Place, Mea Shearim, Jerusalem	159
Under the Olives	161
Butcher's Stall, Mea Shearim, Jerusalem	163
Man from Bokhara	165
The Drinker	167
Joseph Pennell	169
Louis Michel Eilshemius	171
Self-Portrait	173
Yemenite Rabbi	175
R in Pensive Mood	177
Cornfields and Willows	179
Connecticut Woods	181
Apple Trees	183
Woodstock, New York	185